How to Paint with
MARKERS

How to Paint with
MARKERS

Claude de Seynes and Jean Naudet

Watson Guptill Publications/New York

Copyright © 1990 by Parramón Ediciones, S.A.
First published in 1990 in the United States by Watson-Guptill
Publications, a division of Billboard Publications, Inc.,
1515 Broadway, New York, New York 10036.

Library of Congress Cataloging-in-Publication Data

Seynes, Claude de.
 [Así se pinta con rotuladores. English]
 How to paint with markers / Claude de Seynes and Jean Naudet.
 p. cm.—(Watson-Guptill artist's library)
 Translation of: Así se pinta con rotuladores.
 ISBN: 0-8230-2471-7
 1. Dry marker drawing—Technique. 2. Felt marker drawing—
Technique. 3. Painting—Technique. 4. Dry marker drawing—
Technique. I. Naudet, Jean. II. Title. III. Series.
NC877.8.S4913 1990
741.2'6—dc20 89-48708
 CIP

Distributed in the United Kingdom by Phaidon Press Ltd.,
Musterlin House, Jordan Hill Road, Oxford OX2 8DP.

Manufactured in Spain
Legal Deposit: B-45.238-89

1 2 3 4 5 6 7 8 9 10 / 94 93 92 91 90

Contents

Preface

Intellectual work, when it is creative, requires a complete dedication. Fortunately this dedication does not endure, because —as Payot said— "the time for real work is short."

This statement comes from the French thinker and philosopher Jean Guitton. In his book *Intellectual Work,* he considers creativity an attitude that requires brief but intense concentration, like any intellectual activity.

Jean Guitton's ideas perfectly fit the artist's work, particularly when the draftsman or painter is doing a rough sketch. As such, it has to be done in two or three minutes at the most, and it means an exciting moment of tension and agitation for the artist. Concentration must be absolute to grasp and memorize the subject, to let the hand draw lines, shapes, and masses on the paper. A sketch is even more exciting because it has the added challenge of color and its uncertainties. Courbet was right when he said: "I always paint in a state of excitement."

This tension and excitement of creating, this need for drawing and painting at the same time, without pausing, in a limited time, working with shapes and colors, is inseparable from drawing and painting with markers. This is a procedure whose techniques very often coincide with those of watercolor painting.

How to Paint with Markers offers the illustrator and the artist a scope I consider indispensable for success in both fields. I also suggest that teachings in this book are both instructive and challenging, interesting for both the professional and the amateur artist painting landscapes, portraits, figures, and still life, whether with oil, watercolor, pastel, or chalk. Used with mastery of its possibilities and techniques, the marker is the ideal means to project, outline, and paint a smaller version of the final picture. There is a mistaken idea about the chromatic possibilities of painting with markers: many people consider this medium childish, with a color range limited to striking, brilliant colors like mauve, yellow, red, blue... But nothing of the sort is true. Fortunately there is now this book, which uses images and examples to demonstrate the possibility of obtaining any range of colors as if painting with oils, watercolors, pastels, or chalks.

It is only a matter of knowing the methods, the materials, the techniques: in other words, everything this book explains and teaches.

Claude de Seynes and Jean Naudet, the authors of *How to Paint with Markers,* specifically explain the art of *painting* with markers, and I emphasize the word "painting" because the reader will not find instructions on drawing. This ability—knowing how to draw—is taken for granted.

I believe this specific dedication to painting with markers is beneficial from the teaching point of view, considering that Claude de Seynes and Jean Naudet have done such a good job, the former with his superb examples and step-by-step demonstrations and the latter with his clear, concise text.

José M. Parramón

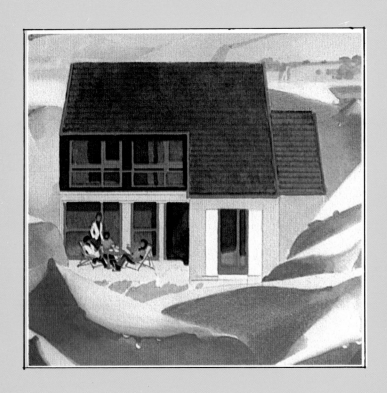

INTRODUCTION

A layout, quick!

Year after year, professional illustrators witness a constant evolution of the materials they use, planned and designed to simplify their everyday work and improve their creativity. This book is about markers, a medium we could call revolutionary from its results. The history of the marker starts in the 1960s.

It was only logical. Someday somebody with an analytical mind would create a pen or brush capable of containing enough ink to permit its use anywhere, anytime, without a constant return to a palette or tin of paint.

The first fine-point marker appeared in Japan in 1963. It was specifically meant for writing. A year later we find a marker with a broad beveled tip, soon a popular tool at offices, to label packages and envelopes. It was not seen as a drawing instrument at all, and it usually came in four colors: blue, red, green, and black. We had to wait until 1968 to have the first marker "for drawing," which was nearly the same as the marker already described but with a more sophisticated tip and available in a wider range of colors.

Like any other invention, the marker for drawing was not only a technical achievement but also an answer to a specific need of a specific market, that of advertising. To learn more about markers, we will examine the different stages of the advertising process in which this drawing instrument so often plays an important role. Nothing is more instructive than following the lead of skilled professionals. This book is based on their experience, and their teachings answer very specific needs to be detailed later. Once you have learned how to work in this medium, it will be time to develop your own creativity unhampered.

A layout, quick!

When an advertising agency, a designer's office, or an independent graphic designer has to develop a publicity project for a customer, the need for an approximate idea of the final project arises. The result is a layout, a sketch, or a rough.

This phase of presenting the project and discussing it with the customer is unavoidable; that is why the layout artist is an efficient craftsman. But how were the sketches done before the marker came along? They were often done in pencil, quite a poor medium for rendering an idea for an advertisement that is meant to be in color, and probably a costly procedure. Sometimes gouache was used, but this is a slow method and the colors take a long time to dry. What happened then? Because of these doubtful means, the designer often lost a prospective customer. Then appeared the marker, an instrument that enabled the layout to be ready almost "on the spot." No wonder the marker became popular quickly and replaced watercolor, most of all among younger artists. A 1981 survey among 6,000 European graphic artists showed this very clearly. Of the systems used for sketches by illustrators under 35 years of age, 52% used markers; 11% used watercolors. Among illustrators over 40 years of age, 38% used markers; 22% used watercolors.

The use of markers became popular starting in 1981, and some artists specialized in the technique. Layout artists have also taken to color markers as invaluable tools for producing countless quick sketches for clients.

A layout, quick!

Speed
The marker is the ideal instrument for making a fast color sketch of an illustration because:
—its semi-rigid tip is able to cover big surfaces evenly
—its ink is self-feeding
—its ink dries fast, allowing the juxtaposition of colors almost at once without smudging or fading with time.

Mastery of stroke
The need to work fast requires that the layout artist have good drawing skills, since his characters or elements must be as convincing as possible. But realism does not mean lots of detail.
To show a concept to a client, you need not adopt a photorealistic drawing style for your quick sketches; otherwise a professional photographer could do the job. There is also the risk of the customer not finding in the final picture the details portrayed in the "rough" drawing. That is why layout artists form two groups or schools: those who prefer a very detailed drawing and those who say what they mean in a few strokes.

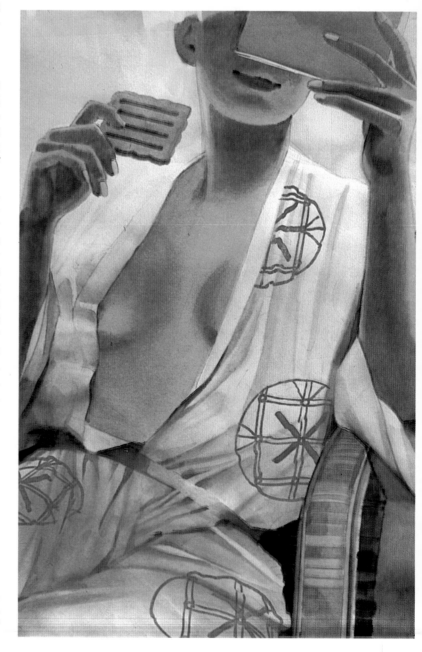

Layout done with markers for a food advertisement. On the facing page (bottom left), the advertisement as published in the media.

A similar case to the one described on the opposite page: the illustration below (1), done with markers, was used to create the advertisement partially shown at the bottom of the page, right (2).

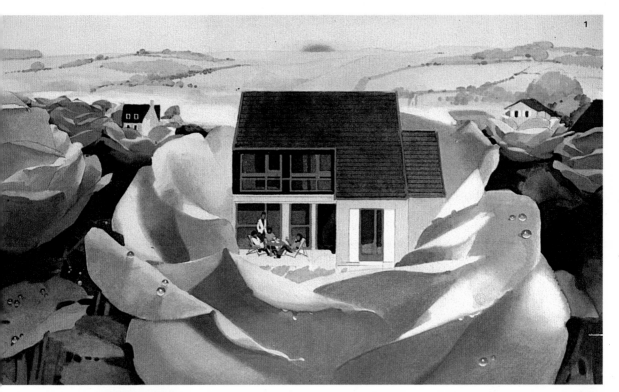

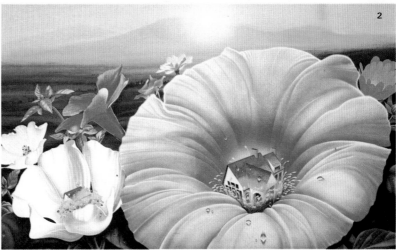

A layout, quick!

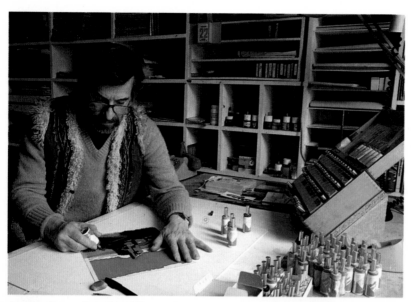

Claude de Seynes, coauthor of this book and expert layout artist, in his studio.

Accepting the fragility of a rough

A rough is used to suggest an idea and illustrate a concept. Once it is accepted, it is passed on to the photographer—or to the illustrator, if the final goal is a drawing—so that he can translate it, adhering to the original idea. When this stage is complete, the rough may be in a deplorable condition, but a rough is not meant to last. Nearly always it is discarded after the publicity campaign is over.

Anonymous work

The layout artist works for others, carrying out orders. He is in close relation to the art director, who asks for a rough. He does not sign his work; it would be meaningless, since it will not be published. On the other hand, the photographer who has materialized the layout artist's idea may sign his picture.

Claude de Seynes, coauthor of this book, is a layout artist. He belongs to the group of humble but very talented artists mentioned in this chapter. We should follow his career closely to benefit from his experiences, which will help achieve the desired mastery of the marker.

MATERIALS

Paper

Paper

Paper, usually taken for granted by most people, is a close and beloved friend of the draftsman and artist. This is especially so in painting with markers, a technique in which the artist can easily fail without the right kind of paper. It was a challenge for the manufacturers to produce a paper that would accept the inked felt tip of the marker without absorbing too much color while being slightly transparent.

The kind of paper to be chosen will vary according to the kind of markers to be used, whether water- or alcohol-based.

Alcohol-based markers

Ever since markers came onto the market, paper manufacturers have had to produce a paper that would answer several requirements:

—The marker should glide, and the paper should be fine, grainless, well-calendered (burnished so that its surface is smooth).

—The ink from the marker should not spread over the paper surface but penetrate it and stay wet enough to blend with more ink being applied. The paper, then, should be absorbent.

—The ink should dry fast (remember, you work fast with large strokes) but not too fast, so we can return to a color, extend it, and gradate it.

—The subject we trace (or the one used as inspiration) should be visible through the paper, that is to say, the paper should not be completely opaque.

—The ink absorbed by the paper should not stain the sheet behind. The manufacturers have evolved a special kind of paper featuring a protective layer or film on the back. This special paper comes in single sheets or in pads under different names. Most have an indication such as "marker," "layout," "sketch."

Sizes are as follows (approximate U.S. equivalents are shown in parentheses):

A4 210 × 297 mm (8½ × 11 in.)
A3 297 × 420 mm (11 × 17 in.)
A2 420 × 594 mm (18 × 24 in.)

In some cases this paper comes bound in pads with TV screens printed on the back of each sheet. It is easy to guess that it is meant for storyboards for films or advertising spots for TV, both usually drawn with markers. My advice is to try different kinds of paper, even those that are not specifically meant for markers. We can then have an idea of the advantages and disadvantages of each and see the way the same color varies on different kinds of papers.

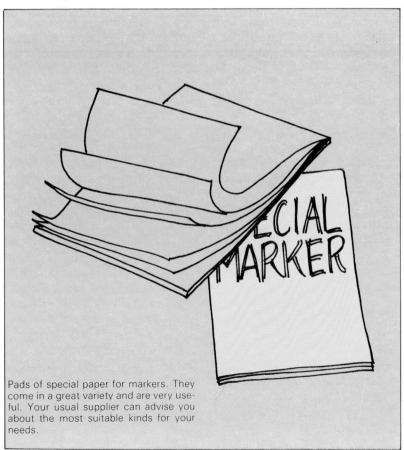

Pads of special paper for markers. They come in a great variety and are very useful. Your usual supplier can advise you about the most suitable kinds for your needs.

Water- and alcohol-based markers

White or colored paper?

American architects who decided to use markers to color their drawings discovered the trick of having their plans colored too when reprographed. In reprography a drawing copied on diazo paper is developed with ammonia vapor, and several copies can be obtained. In other words, an unsatisfactory color can be changed by redeveloping a copy. Development at a normal rate produces a white background with reddish, brown, or black traces, depending on the kind of paper used. These architects, whose drawings are usually very stylized and seldom realistic in their presentation, use this paper as colored paper through a simple trick: accelerating the copying process. The ammonia then has no time to burn the developed areas and gives an even hue (yellow-light brown, pink, or grey) to the paper. This saves time, even more so if the color of the paper corresponds to the dominant color the drawing is meant to have. It is also a good expedient when we want only the center of the illustration colored—as in an unfinished rough.

There is no doubt that to obtain the maximum brilliance and luminosity from the colors of our markers it is better to use white paper. Some draftsmen prefer to reduce the somewhat strident brilliance of the markers with a pale grey paper. Working with white paper will allow us to explore the whole range of colors and their possibilities.

This is the solution we have chosen for the sample exercises.

Water-based markers

These are the most commonly found on the market, and they are intended for children. Later on we will see how to do a rough with these markers. Which is the best paper for water-based markers? At first mention one would say paper for watercolors is the best, but this is not so. This kind of paper is textured, and the tip of the marker cannot leave an even trail if the surface is not smooth. The paper should be satiny but not like paper that owes its luster to a waterproof film. As we have already said, the essence of painting with markers is in the ink being absorbed by the paper and drying more or less rapidly.

A word of warning: water does not evaporate as quickly as alcohol and the paper may cockle while drying. Fortunately, manufacturers long ago created a special kind of paper for markers, adequate for both water- or alcohol-based types.

What is a marker?

As we have said, the marker is a Japanese invention of the early 1960s. This should not be a surprise, since the Japanese write with brushes, and the marker, with its semi-rigid tip, is the natural result of the evolution of the brush. It would be more accurate to call it a felt-tip pen, since it behaves like many Japanese brushes. At first, markers were intended for writing, but when versions in several colors appeared, their applications broadened. For example, they were used to write on glossy surfaces (charts, plastic panels) or to enhance certain texts (note the well-known fluorescent textliner). The last innovation in the physical structure of the marker has been the substitution of the rigid tip for a flexible one shaped like a brush. We will talk about it later.

Now let's get to know markers better, their complementary elements, and the broad-tip kind, which can cover large surfaces and allow elaborate combinations of colors.

What is a marker?

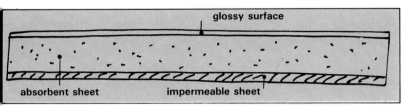

(Left) Cross section of a sheet of special paper for markers. The surface is satiny, the middle is absorbent, and the underlayer is waterproof. (Below) Section of a marker and its cap.

The tip

The expression "felt-tip pen" is misleading, since the tips of markers have long ceased to be made of felt, a too-fragile and soft material. At first, the tip was made of balsa, a tropical wood very often used for scale models. Balsa wood is very resistant due to its special fiber structure. Then the tip was made of plastic, and now the material used is a compensated polyester or other synthetic material, depending on the manufacturer.

A typical marker can draw a line over a mile long!

Finally, let's point out that the tip of a marker has multiple micropores, which let the ink flow through.

The reservoir and the ink

Unlike the reservoir in a regular fountain pen, that in a marker contains a felt wick saturated with ink that flows toward the tip by the process called capillarity. It is still possible to find some old markers with a glass reservoir where the felt wick is visible.

We have previously distinguished between the water- and alcohol-based markers. The "alcohol" meant is really a solvent called xylene. We will later see other peculiarities belonging to each kind of marker.

Alcohol-based inks

These inks have the natural tendency to evaporate, and that is why the cap should always be replaced after using the marker. This advice is even more important for bigger markers with bigger tips. Some manufacturers say that their products can last up to four years and others say ten years. We will not argue, but it is essential to keep the marker carefully capped and away from any heat source.

Choosing markers

Choosing markers

Even if we tend to use fine-tip markers regularly we should also have some broad-tip ones for the foundations of our drawings. There is a wide variety of excellent makes, and your regular supplier may be able to advise from his experience, but in the end, it is only the individual who can decide the best kind for his purposes.

Logically, we should choose a make and type offering at least ten different colors. Remember, we need many different hues to make a convincing drawing.

As a rule, the makes with the biggest variety of colors average 10 to 20 grey tones and 5 to 10 flesh tones. This is something to take into account, since we may not need such a big variety at first, but as we progress in our practice it will become more and more demanding. Because of their originality (the reader will decide whether this is an advantage or not), let's point out the Magic Marker line of products. It is one of the oldest makes on the market. The product consists of a transparent container with a screwed

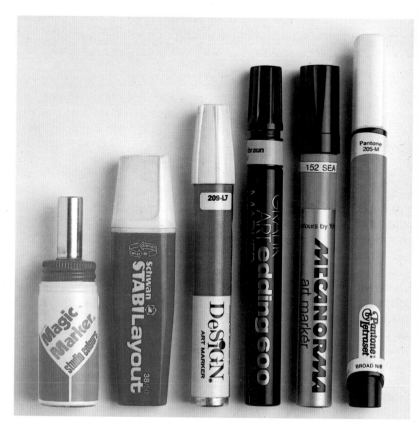

cap and the tip coming through it. The reservoir is rechargeable as long as the tip is not worn out, and the ink can also be applied with a brush when the background to be painted is very large.

On the right is a list of some well-known makes to be found in the shops.

Small selection of some of the markers obtainable from the average supplier. Notice the difference in size, capacity, and even physical appearance of each marker.

Choosing colors

Fine-tip markers

To complete our stock we will need a few markers with medium-size tips (to color small areas) and some fine-tip markers for tracing and outlining. The large manufacturers offer a wide range of fine-tip markers in the same colors as the broad-tip ones. A functional curiosity: the ink in fine-tip markers contains a different solvent allowing the tip to go over the ink deposited by the broad-tip marker without getting mixed with it. The fine-tips draw lines from 0.2 to 0.8 mm wide.

Choosing colors

Use will help us determine which colors we prefer and which adapt best to our needs. Let's keep in mind that the tones used in the illustrations done with markers are not those of oils or watercolors. We should not be lured by the attractive boxes so common on the market since the colors are usually too vivid. As with watercolors, painting with markers should begin with the paler tones, moving on gradually to the darker hues. Let's buy our markers one by one, choosing each one separately, trying them first and starting with the pastel tints. Then we can continue with the green tones—for landscapes—and the flesh tones—for portraits. Let's not forget the greys, so necessary for the shadows (warm greys with red dominant and cold greys with blue dominant). Pages 26 and 27 show a selection of 34 colors, although the 23 marked with an asterisk would be enough to start our practices.

SOME MAKES OF MARKERS		
Manufacturers	Number of colors	Water- or alcohol-based
Edding 600 (Graphic Art Marker) UK	89	A
Magic Market (Studio Colours) UK	123	A
Mecanorma (Art Market) France	116	A
Letraset Pantone USA	203	A
Stabilo (Stabilayout) Denmark	70	W
Young Artist (Boots) Italy	—	W
Colour Scribe (W. H. Smith) Italy	—	W

Each manufacturer has his own system to refer to the colors of his chart, so the one on the following pages in merely indicative. The same applies to the colors, since printing may alter and change particular hues. It is not a good idea to depend completely on the charts supplied by the manufacturers or even on the labels naming the color on each marker. The colors will rarely be the same as in the original ink. We might just as well make our own color chart, painting small squares with the new markers and then indicating the following data: make, name, and reference number.

Three Mecanorma markers, fine-, broad-, and medium-point (from the bottom up). Available at any art supply shop.

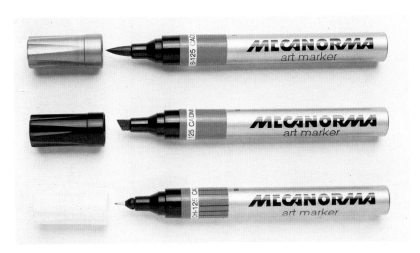

Choosing colors

PANTONE color markers

Letraset carries the widest range of color markers: 203 broad-tip types (white cap) or fine-tip (black cap). The ink flow is constant and steady, and once applied, it dries quickly. The colors in the fine-tip models can be applied over those from a broad-tip marker without running or blending. The shape of the marker makes it pleasant to use, thanks to its original design for use in drawing. The body of the marker indicates its colors. The following three pages feature the 203 broad-nib models by Pantone.

Pads of drawing paper

The Letraset drawing-paper pads are especially designed for work with markers. The ink does not penetrate the paper, and it cannot stain the following sheet. The super-white paper is translucent (for tracing) and at the same time adequately opaque (to highlight the color used). The pads come in units of 50 sheets and sizes A2, A3, and A4.

On the facing page is a picture of a small collection of markers such as you can normally find at your supplier. There are so many different makes ranging from the inexpensive intended for children to those costing much more and intended for the artist designer that it is impossible to mention more than a few typical ones. Of the 123 Magic Marker colors, 48 are now available in "Slimgrip" form, which is perhaps easier to handle than the standard shape.

This and the next two pages feature the whole range of Pantone markers, one of the best-known on the market. (See actual size of marker in picture below.)

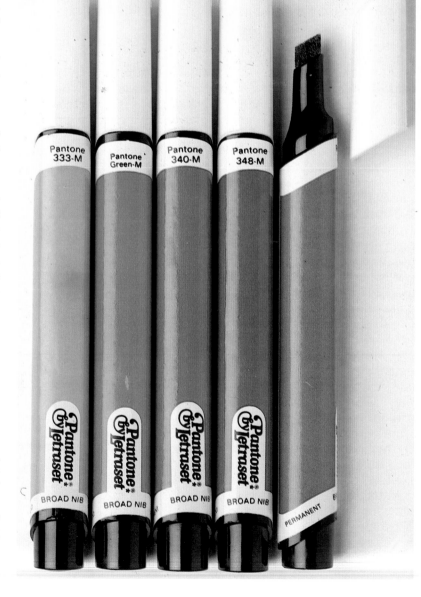

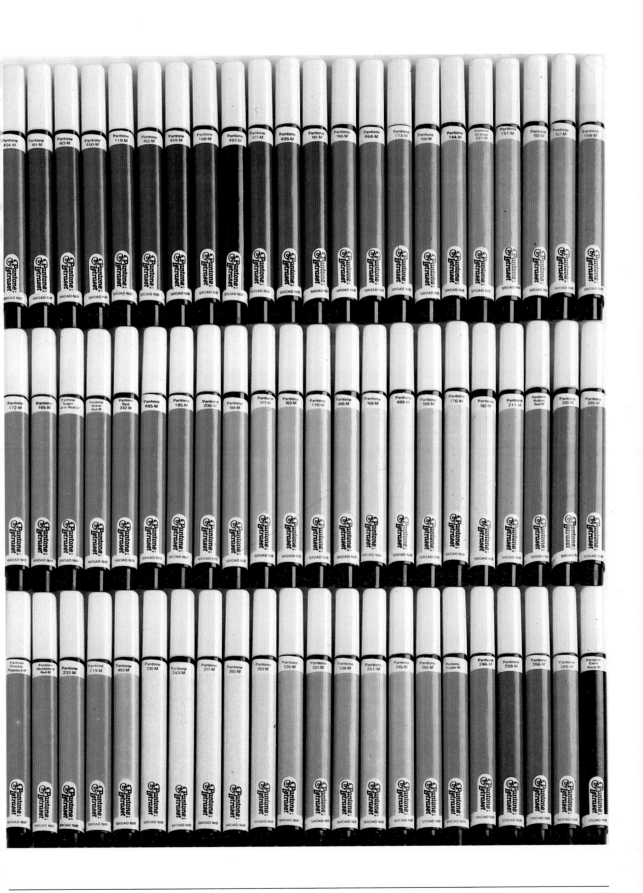

Choosing colors

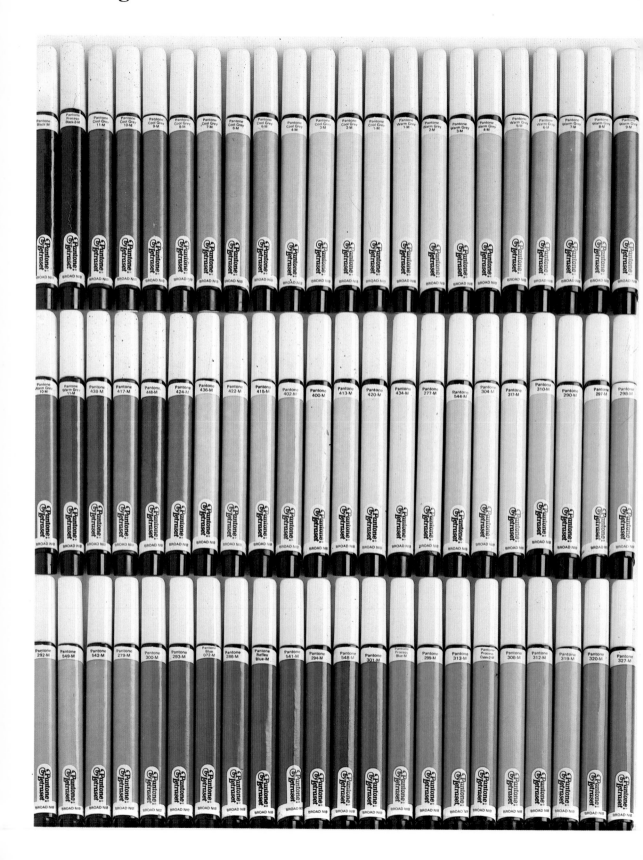

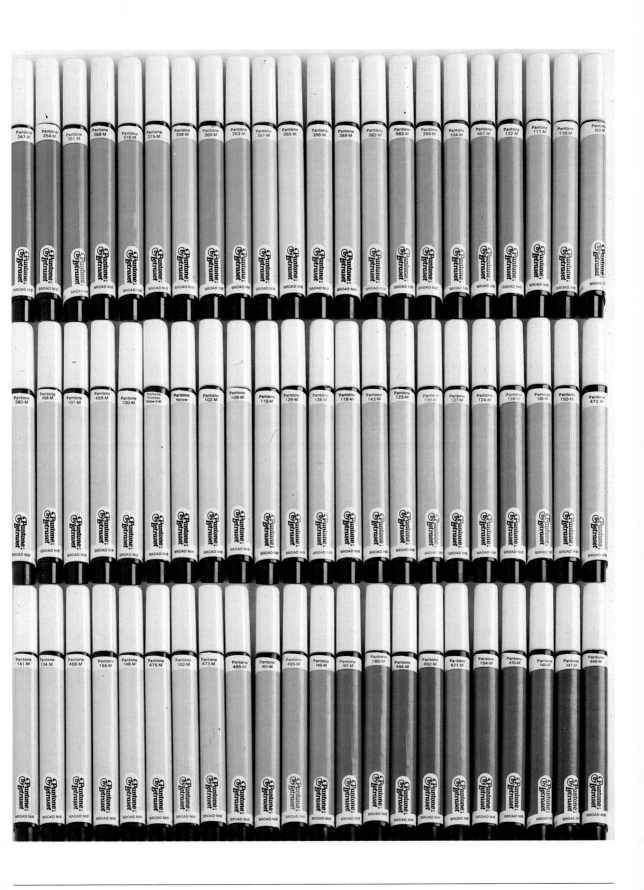

Range of colors

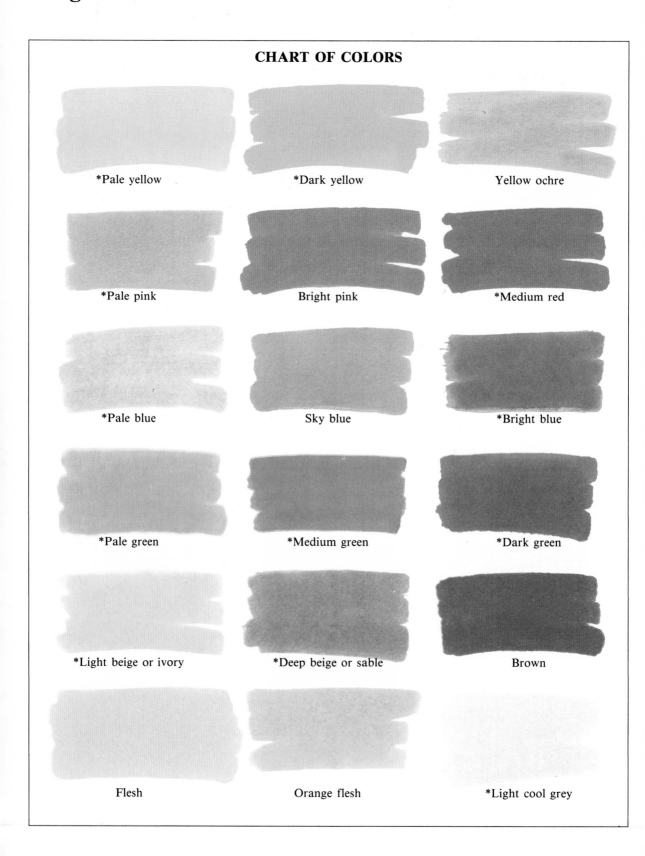

CHART OF COLORS

*Pale yellow *Dark yellow Yellow ochre

*Pale pink Bright pink *Medium red

*Pale blue Sky blue *Bright blue

*Pale green *Medium green *Dark green

*Light beige or ivory *Deep beige or sable Brown

Flesh Orange flesh *Light cool grey

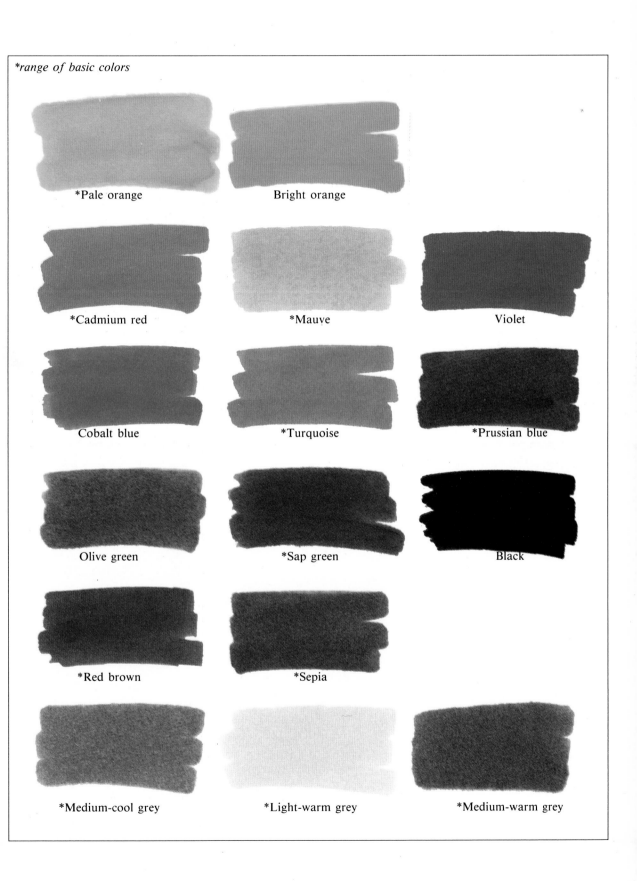

range of basic colors

*Pale orange

Bright orange

*Cadmium red

*Mauve

Violet

Cobalt blue

*Turquoise

*Prussian blue

Olive green

*Sap green

Black

*Red brown

*Sepia

*Medium-cool grey

*Light-warm grey

*Medium-warm grey

Visual references

Visual references

Painting with markers is often done on paper that is not very opaque and allows tracing the subject underneath. It is a good idea, therefore, to assemble beforehand a careful selection of pictures, drawings, and press clippings: in short, to start what will become a growing file of visual references. Advertisements in magazines offer a remarkable number of subjects that deserve to be kept because of an unusual expression, a perfect posture, or the beauty of the light in a certain picture.

As an example, we include the system used by Claude de Seynes to organize his document files. Seynes is considered a great professional and must be able to fulfill any order quickly. It is a easy to see, then, why he is interested in keeping all kinds of reproductions—from a Chinese pagoda to an American skyscraper, from a fisherman with his rod to a golfer. On the other hand, should it be more convenient for us, we can create files for different subjects (still life, landscape, portrait) and organize our files by this system.

Painting with markers does not mean it is unnecessary to know how to draw. Quite to the contrary. But a subject (a picture, a previous illustration) will save us time. Every painter and illustrator uses the possibilities offered by actual photography, although this adds the cost of a model for each subject.

A good file of illustrations classified according to subject allows you to make compositions like the ones shown in the picture at the bottom left without having to go to the original source.

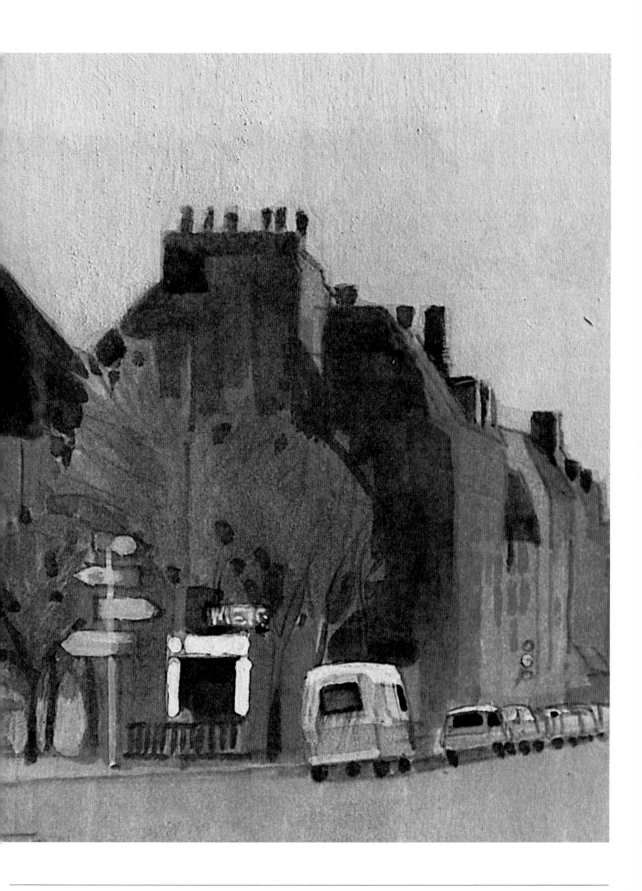

Visual references

Here is the way Claude de Seynes organizes and groups his files of visual references:

People (men, women, children)
—figures and heads
—clothing and fashion

Animals
—domestic
—wild

Houses
—buildings
—individual homes

Public monuments
—buildings
—bridges
—urban elements (benches, lampposts, etc.)

Interiors
—walls and windows
—furniture
—domestic appliances

Transportation
—trains and underground trains
—buses and lorries
—cars
—bicycles
—aircraft
—ships

Work
—men at work
—factories
—office equipment

Nature
—landscapes
—flowers
—trees and forests
—water and sea
—fire
—sky and clouds

Still life
—fruit and vegetables
—food
—fabrics
—flower and vases

Leisure
—sports
—games

As soon as we have decided on a minimum number of files, we will want to subdivide them into complementary subjects. It will then be time to substitute folders for cabinet files and drawers for shelves in our bookcase.

All kinds of pictures, illustrations, clippings, postcards.... We can start our working file with this material, a pair of scissors, and a little imagination.

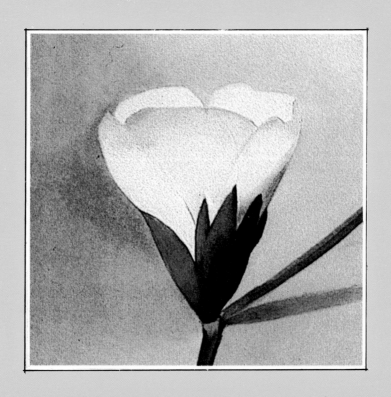

TECHNIQUES

Preliminary steps before drawing

Marker arrangement

When overlaying colors on the paper, the tones change, although slightly (the darker hues always have an advantage). With markers, then, it is always necessary to use the desired color directly, as one is not able to make previous mixtures as with watercolor or gouache.

Sitting at our table, ready to start working, we should have enough markers conveniently arranged so as to be able to find the desired color easily. All markers, whether they come as pens or in flasks, have a more or less reliable label indicating the color of the ink they contain. It is worthwhile to classify them by groups or "families" (for example, yellows with oranges) and keep them always in their places so we can find them every time we need them. The manufacturers offer systems to keep the markers upright on the table, since they always tend to roll and fall down (we suggest a shallow tray like that for developing photographic paper). As for the flasks, they stand easily and many artists keep them in big film tins (they are circular and very practical). No need to remind you that *all* markers should be tightly capped when not being used.

The work table

Shall the working table be horizontal or sloping? It will depend, of course, on individual habits, but we suggest you use a horizontal surface for two reasons: first, on a sloping surface, markers roll off and fall down, as we have said before, and let's recognize that they are never put back in their right place immediately after use; second, as we will see later, it is always more practical to work on a surface parallel to the ground.

Lighting

As in any other painting technique, the best light for working with markers is daylight. Colors look purer, fresher, and most of all, more real. Let's move over to the window, then, and open it a little if we are working with alcohol-based markers. It is not that the vapors of the product are harmful, but they can become a nuisance after several hours of work. For the same reason we previously recommended water-based markers for artists with a hypersensitive sense of smell. Prolonged exposure to even low concentrations of xylene vapor can be harmful.

Detail of a broad-tip marker. The dotted lines indicate the surfaces that produce the three kinds of strokes illustrated on the next page.

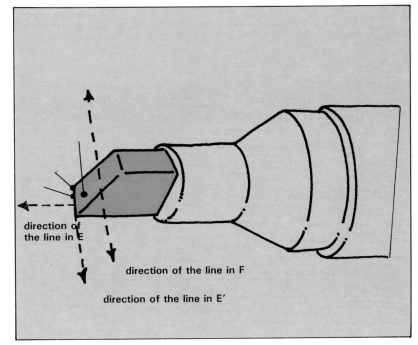

direction of the line in E

direction of the line in F

direction of the line in E'

A drawing as a basis

How to handle a marker

The broad-tip marker has a rectangular, sloped wick similar to the bristles in some brushes, although all possible comparisons end there. Handling a brush requires flexibility but handling a marker calls for rigidity. The nib of the marker, then, has two working parts (labeled E for edge, and F for flat).

First requirement of handling a marker: that part of the wick being used must be wholly in contact with the paper (that is, all of part E or F) while drawing any line.

The illustration shows the two ways we can use part E. The manufacturers supply three different widths, usually 1, 3, and 5 mm. For colorful details, we will use edge E, although very cautiously, because it is not very rigid, and it crushes with pressure (see illustration). For thinner lines, however, we have a specific tool: the fine-point marker. The need for constant contact calls for rigid marker and wrist (both together) with the pen kept perpendicular to the paper. This perpendicularity is somewhat theoretical since the wick is beveled, and the contact of F with the paper forces a slight inclination of the marker. For the same reason, when we use E, we try not to touch the paper with F, and then we tend to incline the marker a little the other way. Keeping these conditions in mind, we will hold the marker as if it were a pencil, but placing the fingers close to the tip so it will be like a continuation of the hand. This forward positioning of the

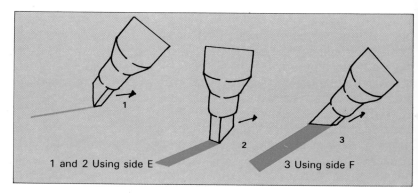

1 and 2 Using side E 3 Using side F

fingers allows us to rest the ring finger and the little finger on the paper, thus gaining more support and firmness when drawing lines. The medium-point and fine-point markers are held exactly like a pencil.

Handling the brush-marker is completely different, and to draw a line the tip hardly touches the paper, while the same tip must be pressed over the paper to broaden the line or stroke, as we will describe later.

A drawing as a basis

Nothing prevents us from using the marker directly on the paper without a previous drawing. If we use the marker as if it were a pencil, we give the illustration the appearance of an improvised sketch. However, if we would rather produce a more elaborate drawing, we should first draw—as with watercolors—the structure of the objects or elements, defining them according to their distance.

Three strokes from different ways of using a marker. (Below) Universal grading of the pencils available on the market.

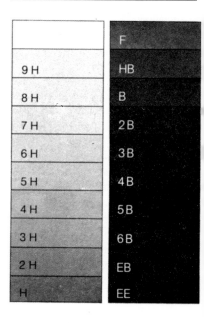

INTERNATIONAL GRADING OF PENCIL LEADS

	F
9 H	HB
8 H	B
7 H	2 B
6 H	3 B
5 H	4 B
4 H	5 B
3 H	6 B
2 H	EB
H	EE

H: Hard, and therefore not greasy (it contains more clay)
B: Black and greasy (it contains more graphite)
E: Extra

An adequate pencil

After that, the only thing left is to color the outlined spaces. Here is where the functions of the marker come into effect as they were described at the beginning of this book: painting a previously drawn rough.

How to go about the basic drawing

We will start with a pencil so we can erase, modify, and alter. Later, the pencil lines are covered with the fine-point marker, before or after adding the final color.

The professionals who use the fine-point marker directly instead of the pencil (architects, for instance) consider the result as final, so it is important that the drawing be without last-minute additions. Color will only be used then to highlight the illustration. When applying it we should not go over the limits set by the black marker. These previous lines are very visible until the end of the coloring process.

Pencil outlines are weak but nonetheless visible under the ink. If the colors overflow those limits, we can always redefine them with another black marker after the colors have been applied. The drawing will then become more forceful. Some artists, like Claude de Seynes, prefer not to redefine outlines in already colored drawings, thus, giving them a freer, "looser" style, more like paintings.

An adequate pencil

It should be black enough to be seen under the colored ink. Be careful; the black should be intense but not greasy. If it

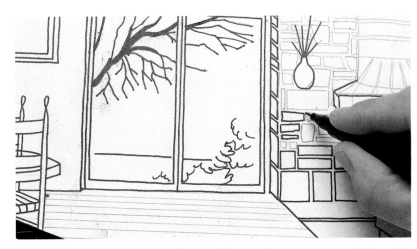

were, the graphite deposited on the paper could mix with the ink and make it dirty. The ideal pencil is an HB, the best for drawings and sketches. A harder pencil could ruin the paper.

Complementary elements

It is evident that we will not always succeed at a first attempt with our roughs. In this respect, remember we mentioned the possibility of working with a special kind of paper, slightly transparent, that allows the tracing of subjects previously drawn. To create a very elaborate illustration, full of details, we will first work on a series of sketches, studying the different subjects that form the composition, changing and improving the drawing with successive tracings. Here we recommend once more the already mentioned file of visual references.

The images we may have collected are not necessarily of the size we need for our drawing. In such cases, we can use any of the available systems of reproduction that magnify or reduce the size of the image according to our requirements.

The preliminary step to painting with markers is drawing the subject with a pencil and then outlining it with a fine-point marker.

The parallel technique

The drawing technique
The way we apply the ink is what we would call "treatment" in painting, and it greatly depends on the artist's inspiration. Some paint with large brushstrokes and others use light and successive touches with the brush. Anything goes with markers, even pointillism, but their nature leads to wide strokes. Why? Because the nib of the marker is broad and can cover the whole surface of the background paper quickly, leaving the details and outlines for the fine-point markers. There lies the main advantage of markers: the flow of ink is almost endless, thus avoiding all kinds of limitations. In other words, we have no need to move, looking for material. Other reasons justify the quick strokes. If we apply the tip of the marker to the paper and keep it there a few seconds, the ink tends to spread and form a spot. We should thus apply the marker quickly to avoid this overload of color. If we want a darker tone, we can superimpose another stroke. However, we cannot make it thicker since ink is liquid, and it penetrates the paper and colors it.
As a summary, we can separate the drawing strokes into two groups:
—for backgrounds or large areas (broad-tip marker required)
—for small areas and details (medium- or fine-point marker required).

Painting of surfaces
For big surfaces or backgrounds we apply the ink in successive strokes. We can follow three different techniques, depending on our degree of familiarization with the marker. We can practice them as they are described:

—Parallel strokes
—sweeping
—blending

The parallel technique
It is the easiest, simplest technique, the one we recommend to all absolute beginners. The surface is covered by means of parallel strokes or lines, always following the same direction, from top down (1) and from left to right (2). (See illustration below.) If the strokes are juxtaposed, it is only a matter of precaution to avoid any blank spaces. Later, we will see how to avoid the results of superimposition.
Soon we will find out that we use vertical strokes much more than horizontal ones, because it is easier to make regular strokes down than to obtain horizontal parallel ones. A piece of advice: do not hesitate to cover whole pages with

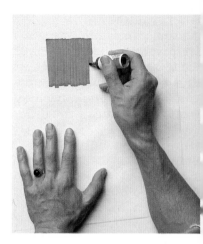

Position of the hands for the parallel technique.

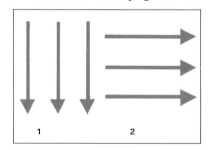

parallel strokes until you feel confident and have mastered the technique.

Children do the same to educate their hands before they start writing.

Here we offer a few examples of parallel strokes. One of them is the Bridge at Chatou (see page 61), in which the crossed lines help create the effect of reflections in the water. See also Castle in the Pyrenees (page 67). Before going on to more complex compositions, here are two easy examples as practice exercises.

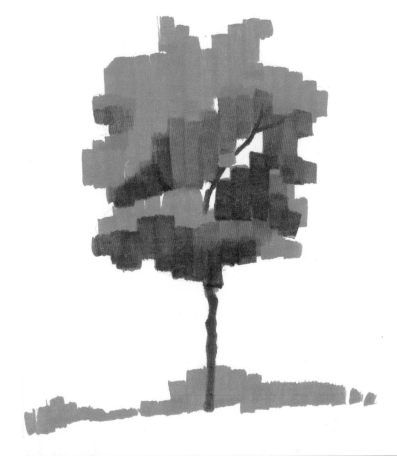

(Right) This is exercise no. 1, explained on the next page. The tree was painted using the parallel technique. (Below) A more elaborate exercise requiring greater knowledge of mixing colors. Notice the always parallel strokes.

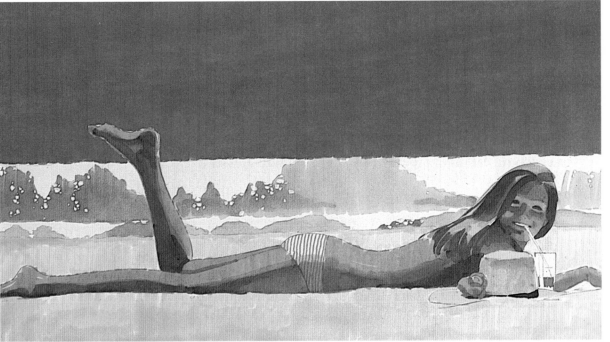

The parallel technique

Exercise no. 1: Tree no. 1

—The outlines of the drawing have been simplified. They should be drawn with pencil or traced.

—We will need three different tones of green (a raw green, a somewhat darker green, and a very dark green). We can vary the combination according to our tastes.

—We will always start with the lighter color, filling the foliage area with vertical strokes produced by the broader side of the nib (F). In this exercise it is not necessary to make the strokes very precise, although they do have to be perfectly parallel and drawn from the top down.

We can do something similar for the grass under the tree with a series of irregular short strokes. The same tone of green should be applied to the trunk of the tree, using the edge of the nib and trying not to go over the outline. Why also the trunk? you will undoubtedly wonder. This is done because the superimposition of the two greens will give density to the dark green areas.

—Use the medium green tone in the shaded areas (necessarily located under or inside the lighter masses of leaves).

—Go back to the center of the drawing and add the dark green touches. Draw the branch (with the edge of the marker) and the trunk.

That's it, we have finished. This drawing is easy to do, and it does not lack appeal. We have surely succeeded at first try, so let's go on to the second exercise.

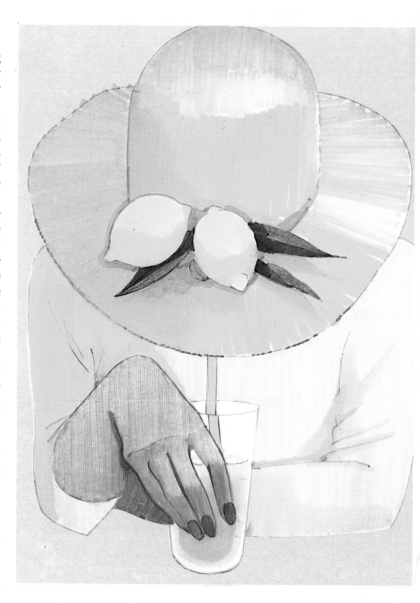

Exercise no. 2: The lemon-colored hat

—Draw the shape with pencil or trace the outline.

—Apply the lighter color— lemon yellow—to the dress, the hat, and the drink. Let's not forget to indicate the rounded border of the hat, placing the tip of the marker parallel to the strokes.

—Add the intense yellow. The

The Lemon-Colored Hat. Example of an illustration done with a basic dominant color applied with the parallel technique.

circular brim of the hat is enhanced by means of concentric strokes.

—The shadow of the leaves and the lemons is done with a second layer of the same yellow.

—Apply both greens and the flesh tone for the hand.

The sweeping technique

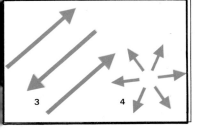

Position of the hands for the sweeping technique. Left: direction of the strokes as explained in the text. Below: example of an illustration done with this way of using the markers.

The sweeping technique
This technique is similar to the sketching procedure in oil painting. Painting is done according to the direction of the object. A tree, for example, is done following the lines of the branches (4). It is an unrestricted technique requiring ability and dexterity for which no precise rules can be imposed. Inspiration gives the lead. We will notice that the movements to and fro (3) are more spontaneous and less parallel. Covering the white of the paper is not the goal, so the sweeping technique is mostly used over already-painted backgrounds. Of course we can always start from scratch to come back later to the "swept" area and finish it off.

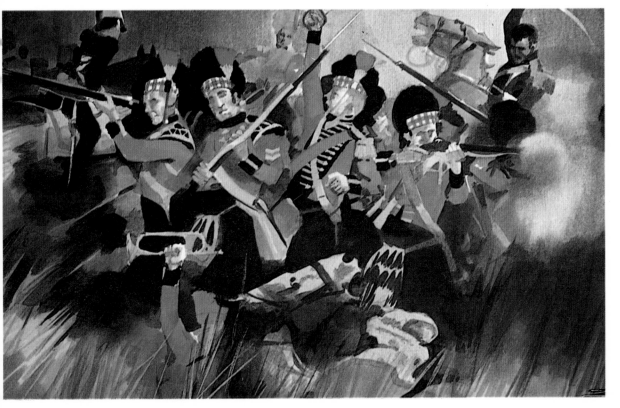

The sweeping technique

We can see the sweeping technique in the practical exercise called the Louisiana House (page 79), in the sketch featuring a group of Scotsmen, and in the next two exercises. These two exercises should not present any problem for us. We can practice the sweeping technique, thus avoiding the stylistic impositions of the parallel technique.

Exercise no. 3: A poppy flower
We will have to draw a few nearly parallel strokes, not from the top down but following the shape of the petals. It will not be a regular sweeping like the one used for exercise no. 4, since the strokes inside the petals do not go to and fro but are drawn, one next to the other, from the starting line. The procedure, however, is almost like sweeping because it is our inspiration that leads our hand when drawing the strokes that form the flower.
Four colors will be enough for this still life:
—a "poppy" red
—a darker red for the shadows (a spot at the top, two at the bottom) and the center
—a black applied in light

touches with a medium-point marker.
—a green for the stem
We will not describe the successive steps, but notice that the pencil outline is very free, including the stem. This is a good example of a drawing as the basis required by the marker technique. The previous pencil outline needs some pre-

cision as a frame for later coloring.
As stated, we will start with the lighter color, painting first the upper part and proceeding downward petal by petal.

(Above) Illustrating a poppy flower, exercise no. 3. (Below) Compare both trees suggested in the previous exercises: left, done with the parallel technique, and right, done with the sweeping technique.

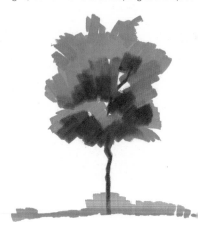

The blending technique

The empty spaces are very evident and spontaneous, giving the flower an undoubted elegance.

Exercise no. 4: Tree no. 2

Compare both trees suggested so far as illustrations: the first one—see the parallel technique—and this one, more disorderly and reminding us of a tree in the wind. No pencil outline limits the foliage. Intuition must guide the artist's hand. As in the previous exercise, we will not go into the different stages in the execution of this tree no. 2. Begin with the paler colors, work on and finish with the darker ones. In this case it is a pine-tree green that enhances the foliage and makes the drawing more solid. Draw several more trees as a complementary exercise for the sweeping technique. The result will differ in each case.

The blending technique

If we do not want the track of the marker to be seen and try to blend the shades of the different colors, we should

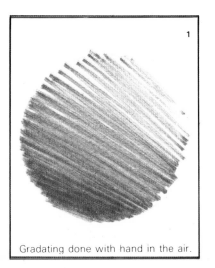

Gradating done with hand in the air.

work "wet-in-wet," which Claude de Seynes defines as applying fresh marker strokes in the same or a different color over a first layer of color that is not yet dry. This allows the second application to blend with the first.

This does not apply, of course, to the blending technique in parallel lines, where the juxtaposition will be more evident when the markers are worn out. When they are new, they spread the ink better, blending it instead of juxtaposing it and so all stripes are avoided. By painting the same spot over a few times, in every direction or in a circular motion, it is possible to obtain a color more intense than the original one and perfectly distributed.

After achieving the blending effect, we may wish to add a little color to clear outlines (a shadow, for example). We will have to wait until the first layers have dried. The blending technique permits results close to those obtained with an airbrush, although it requires some skill.

Alice's Portrait (page 73) was done using both techniques. The first shows traces of the marker and seems less finished but more spontaneous. Now we have two drawings by Claude de Seynes done with the blending technique but with different goals and results. Notice the way the blended grey gives a diffused atmosphere around the flower, showing it as if through haze. The blending permits shading the objects softly and in various degrees. It also allows the look of a strong shadow, as

is the case in the illustration of the gardener done in monochrome. The applications of the different greys are uniform as a result of the blending technique.

The blending technique is clearly illustrated in these two pictures. It allows shading in rich tones and with delicate softness.

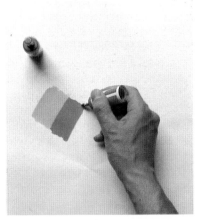

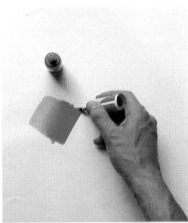

The blending technique

The beach scene on page 37 is another good example of blending, done with several tones of blue. The transparency of the illustration is obtained by overlaying colors while they are still wet. Before going into the details, allow us to emphasize the need for repeated blending until the desired grading is achieved.

Exercise no. 5: Billiard balls
This is one of the easiest exercises since the circles are drawn using a pair of compasses. Then, fill them with light grey and red without going over the edge, moving in all directions until an even tone is reached. Try to keep a white spot to indicate the highlight. After that, go over the shadow part with some darker grey on the outer part to create a graded effect. As we said before, more color means a darker color. That is why it is convenient to use pale tones for blending. Important: if we cannot help going over the edge of the circles we should not overworry. A little white gouache will help us hide those unwanted areas. This is one of the professional tricks we will introduce later on. In the next exercise we will probably have to use this little stratagem.

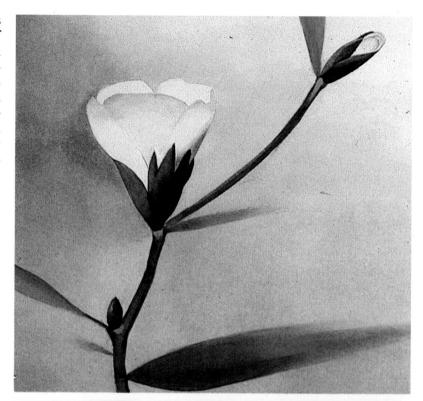

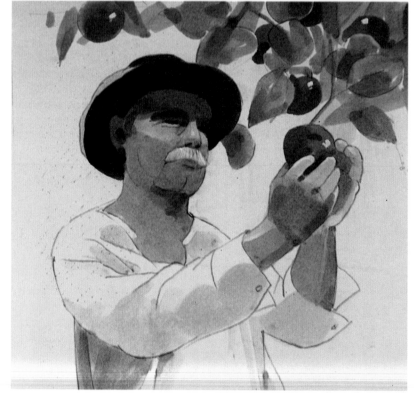

(Facing page) Two perfect examples to illustrate the results of the blending technique. Notice the halo—it resembles a photographic softness—that surrounds the flower. (On this page) The billiard balls drawing is a relatively easy exercise to do. The cup is a little more complex because it requires the use of three different markers.

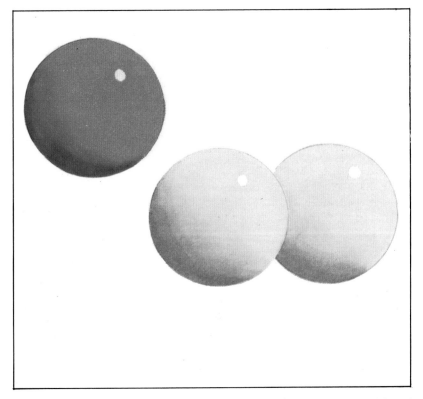

Exercise no. 6: A cup

This illustration is a little more complex and will require much more attention on our part.
—We need three markers:
a soft cool grey
a medium cool grey
a dark brown
—Draw the cup with precision using a pencil (the pencil lines will be the limit when applying color). Remember, in the blending technique we paint in all directions, not to create an appearance of disorder but to allow the still wet ink of the first layer to blend with the next. For the cup, we can use the angular tip of the marker to limit the upper rim of the porcelain and the shadow at the bottom of the cup before applying the color with the broader part of the nib.

The inside of the cup will be less of a problem because the excess ink will hide under the coffee. It is enough, then, to carefully follow the upper pencil line first with the soft grey and then with the medium grey. The shadow of the handle will be medium grey, done with the angular part of the marker called the tip. We can also use a fine-point marker if we are sure to obtain the same tone of grey.

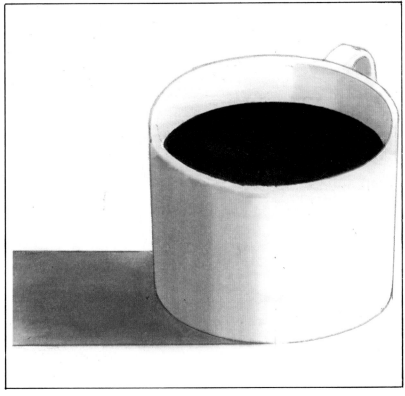

The blending technique

We can not finish this chapter devoted to the techniques of applying markers without a mention of the wick method. If we use flask markers and have to color a large flat background, we can extract the wick, hold it with the fingers, and apply it in its length over the paper. It is a fast, radical system. If the wick still has some ink after the application, we can put it back into the flask.

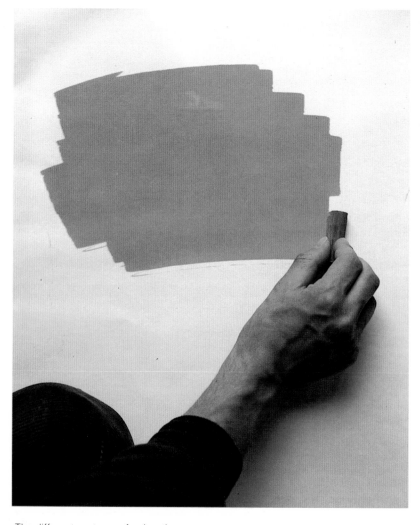

The different systems of using the markers is complete with the one called ''the wick.'' This is taken out of its container and applied lengthwise over the paper to paint large backgrounds.

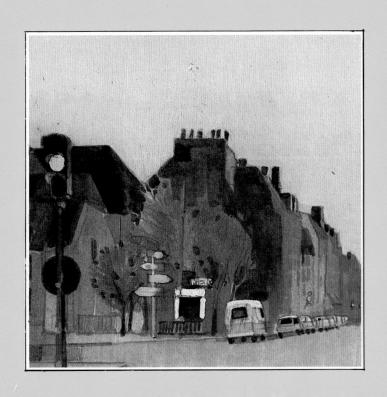

THE FINISH

Details

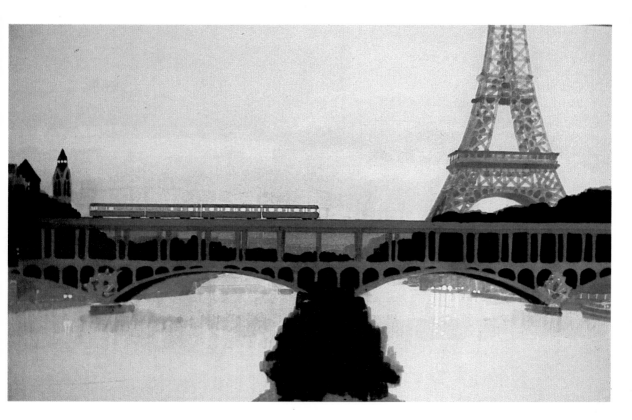

The process for illustrations done with markers follows three steps:
—First, a very precise pencil drawing.
—Second, the application of color with broad-tip markers that cover big areas in successive layers, sometimes juxtaposed.
—Third, the finish, meaning the addition of details and fine lines kept for the end, since they enhance, highlight, and finish the drawing.

Details
Some details should be added at the end for several reasons.
1. The original pencil drawing has been the guide to limit the color areas, usually enough to structure planes and emphasize shapes. When completing the coloring process, however, we can retouch some contours of

the drawing with the marker. The technique is also used in painting. Rouault surrounded his characters with a thick black line. Obviously, this is the last operation of the illustration and is in no way compulsory.
We can make these lines black or any other dark color. If we become addicted to these final outlines, in the end we will find out that we do not exactly cover the original drawing, since the successive layers of color have modified its construction.
2. In the same manner, it is only at the end of the illustration that we can apply the necessary color touches to create contrasts, value tones, and emphasize the light. But first of all we should find out which details are the darkest in relation to the colors used (and ap-

plied with markers) and which are the lightest (and require a technique different from that of the marker). At any rate, we should be very careful and precise. This sort of miniature work contrasts the application of color by means of wide strokes that we described before.

Details

Which marker should be used?
The ideal marker for dark details is a fine or medium point, especially if it is black. In case we do not have a fine-point marker of the same color as the broad-point marker, remember that we can also draw thin lines with the latter using the edge E as already described and the angle of the edge.
For the lighter details we can use gouache with a brush. Let's examine the next two illustrations. The framework of the Eiffel Tower, for example, was done with the hand lifted from the paper, in medium blue, and with the edge of the marker. The details were highlighted later with a darker-color fine-point marker. In the case of Saint Germain, the mauve branches in the yellowish trees and the window panes on the left were done with the small edge of the marker tip. The angle of the same marker was used to add, among other details, the black touches in the foliage to show depth, the tires of the parked vehicles, and the fence of the subway. This is the evidence that a broad-tip marker can do almost everything, even relatively thin lines.

Adding gouache for whites and pale colors
Going back to the paler details, we can of course leave some white areas from the begin-

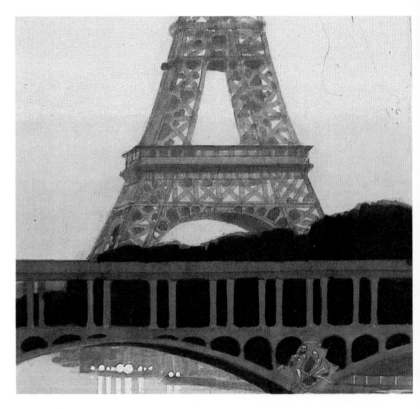

ning, as in the case of the clouds in Bridge at Chatou, the lines in a horizon, the top of snowy mountains, and so forth. When these pale details are very thin or appear suddenly, they are better resolved at the end, but not with the broad-tip marker, since it is not possible to go back to a paler color from a darker one. We can then resort to the complementary technique of gouache.
In the Parisian Saint Germain illustration, the lights of the night still shine in the bluish at-

These illustrations (above, previous, and facing pages) of the Eiffel Tower and Saint Germain were done almost entirely with broad-tip markers, difficult as this may seem. The detailed work of the Eiffel Tower shows that all kinds of thin lines and spots can be done with the edge and profile of the marker.

mosphere of dawn. All the luminous touches were done with gouache: the yellow traffic light (without the yellow wall of the church), the traffic signs, the subway signs reflecting on the van, the sign of the famous Deux Magots bar....

Original picture for the illustrations described on pages 47 and 48. As can be seen, almost any subject can be reproduced on paper with the help of markers.

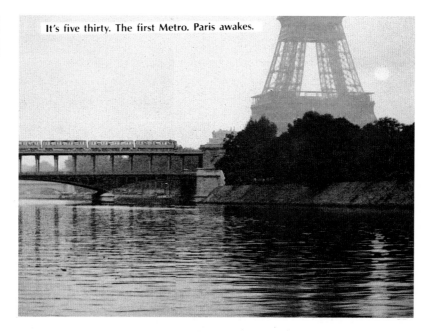

It's five thirty. The first Metro. Paris awakes.

Details

Tropical landscapes, full of sun and color, are particularly suitable for reproduction on paper with markers. This page shows three pictures of such places. Notice the treatment the artist gave to the different tones of water.

Looking at the almost finished composition, we have to decide which light or dark touches are necessary for the finish. The pale touches, then, can be decided at the end, like those white bubbles representing the foam of the waves at the beach where the Girl with a Rose is sunbathing. Notice the classical treatment of parallel strokes in this illustration: the rose in the hat was done with the tip of the marker soaked in ink and applied lengthwise. This procedure excludes the possibility of leaving blank spaces for the clouds beforehand. The cumuli were done in two stages, first with white gouache to shape them and then with light blue gouache to stress the shape. As a last example of the addition of light details we have The Cove. This summer scene is a good example of blending blues that evoke the depth of the sea. The foam of the water and the reflections on the boat produced by the midday sun were done with gouache. In the chapter dealing with

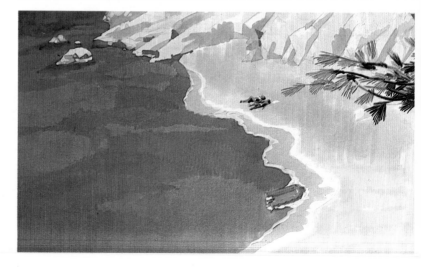

Complementary procedures

ricks and complementary procedures we will see other applications for these final touches.

Complementary procedures

Convinced as we may be of the possibilities offered by the marker, we must recognize that there are also other techniques able to add some more individuality to our drawing. We have already mentioned gouache, and under "professional tricks" we will see others. Now we will study the use of chalk and colored pencil, techniques that are quite different from gouache. The use of these parallel procedures originated with some American illustrators who systematically applied pencil coloring over the marker to lessen the strength of the latter or just to add ornamental touches. Here are some of these techniques:

1. Modifying color

To modify the color applied with a marker we can overap-ply the same color to make it darker or use a neutral grey to soften it. We can also use a different color to change the tone of the first. But if we use a colored pencil over a background painted with marker, we alter not only the color but also its structure, since the pencil strokes have their own rhythm. A good example of this is the illustration of the geyser. The yellow ochre sky was done with successive layers of blue and pencils. It is easy to imagine the range of possibilities for enriching the texture of the drawing that this procedure offers.

The Geyser is a good example of the use of colored pencils. Notice the realistic effect of the hot water hitting the rock.

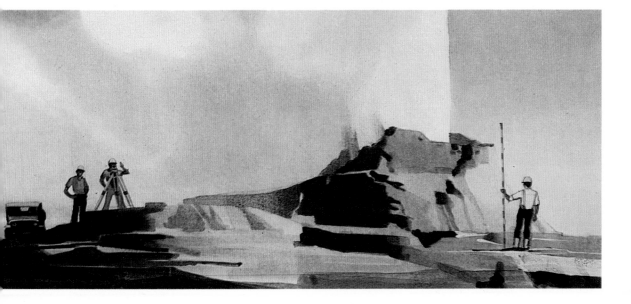

Complementary procedures

2. The hazy effect
A pale colored pencil diffuses a darker marker color, and the more we apply it, the more evident the hazy effect will be. A landscape can become surrounded by haze through the application of a very soft grey, lighter in the foreground than in the more distant areas.

3. Decoration and light
We have just seen how a colored pencil has the advantage of creating different motifs over a marker background. These details can be merely decorative —like the sky in the first illustration—or an answer to a technical need of the drawing, as in the case of the illustration of buildings.

This page offers an intermediate stage of the drawing: the use of a cream-colored pencil to create the white of the cement. A second stage will limit the shadow of the bricks by means of a black fine-point marker.

The white or cream-colored pencil used to indicate the brick joints can also be used in angular areas of monuments or objects to create a thin pale thread that seems to trap the light. Obviously, the pencil used has to be well-sharpened.

4. Brightness
Owing to its physical configuration, the colored pencil will always be brighter than the marker. This is why it is usually recommended for adding brightness to the illustration.

5. Shadows and reflections
In the illustration of an unfinished interior, the parquet flooring was done with a broad-tip marker, but the diffused shadow from the table was done with a lightly applied brown pencil. The reflection from the window was obtained with a white pencil, pressed harder nearer the light than in the foreground.

6. White objects
The previous example is a demonstration of the use of the pencil to create certain effects. Just like gouache, but with even more possibilities, it is also the ideal method for creating thin white lines, for example, a few white hairs in a character, a mass of blonde hair floating in the wind, trees or shrubs covered with snow, water jets (see illustration), etc. But we will not go any further into the introduction of complementary techniques, since the aim of this book is teaching how to paint with markers. However, these complemen-

Application of a white or cream-colored pencil.

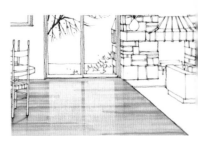

Creating shadows and reflections requires a specific technique, as explained on this page.
(Below) Brightness, light, and shade were obtained with the help of a yellow pencil in this beautiful image.

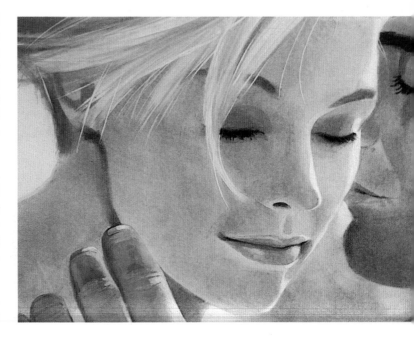

Professional tricks

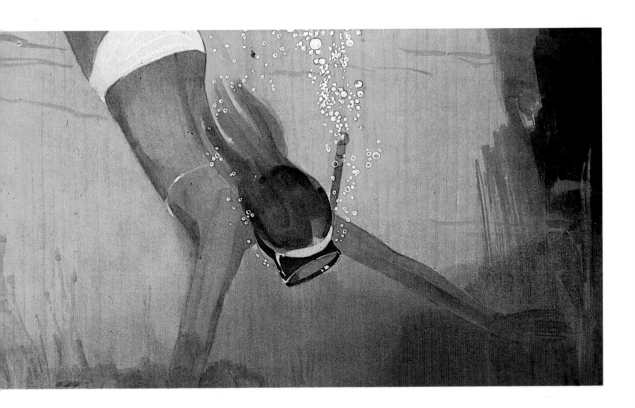

Another professional trick used by artists: gouache helps them to obtain certain effects, like the bubbles in this drawing.

tary techniques deserve to be studied in more detail, mostly because they show us that there is always room for surprises and personal discoveries in the artistic field of markers.

Professional tricks
We shall not master painting with markers until we have explored every possibility. Here is a tentative list of professional tricks, but certainly anyone interested in the subject will be able to discover quite a few more.

Drawing on both sides
If the paper we use is too thin or does not have a protective layer on the back, the color from the markers will pass through and show on the other side. An artist friend of ours usually retouches the stained back, rectifying and adding color, to reinforce the general tone of the drawing on the front. In a way, it means drawing on both sides of the paper.

Marker, brush, and airbrush
The Magic Marker line has markers whose wick can be extracted from its glass container to be applied lengthwise. Once the wick has been taken out, we can refill the flask with ink (bottles containing the more frequently used colors are available) and also apply the color with a brush, and some artists do this often. Finally, we can also use the ink with the special airbrush pen for dull backgrounds and for similar effects whenever the illustration calls for them. Talking about the airbrush, the Letraset company has created a very economical system for applying the ink from Pantone

Complementary procedures

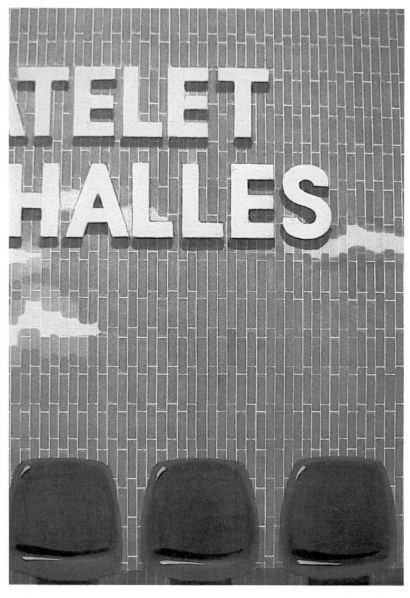

The gouache used for this illustration of part of a Paris Metro station was applied with a ruling pen.

fine-point markers with airbrush-like results but without having to use one of those devices. The name of the invention is Letrajet, and it looks like a beak attached to the tip of the marker and connected to a spray can by a tube.

The stucco effect
To obtain a grainy appearance place some sandpaper or a very thin net under the sheet of paper.

Fading
An irregular fading of the color can be obtained by spreading it with a tissue or the finger while the ink is still wet.

Drawing tiles
For drawing brick walls we need a B pencil, as we have al-

ready seen. The illustration shows a wall in a Parisian Metro station, where the white edges of the tiles required great precision. The problem was solved with a ruling pen and liquid gouache.

Brilliance
To obtain the shiny effect of water taps, car fenders, or greasy surfaces such as lipstick, white gouache is used. Here are two specific exercises as a practical example:
—first, the lips. The teeth were left untouched and the shiny effect of the lips was done with gouache.

Eyes

See here a very academic representation of eyes. The background was softened with liquid gouache, the iris outlined with the tip of a black fine-point marker, and the reflections in the pupils done with white gouache.

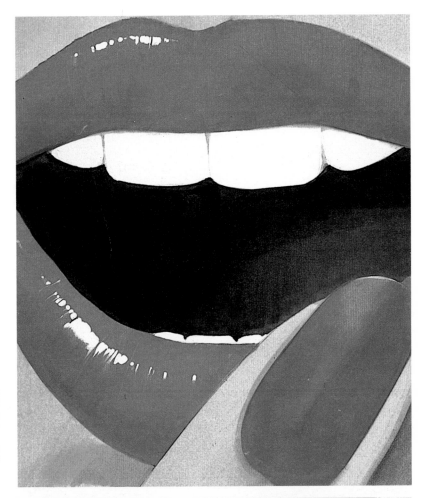

Sometimes the artist has to do a striking job with aggressive colors, very glossy and direct, for commercial advertisements like the one shown here. It is meant to attract the attention of the passerby.
A touch of white in the iris of the eyes makes the portrait more vivid, as shown below.

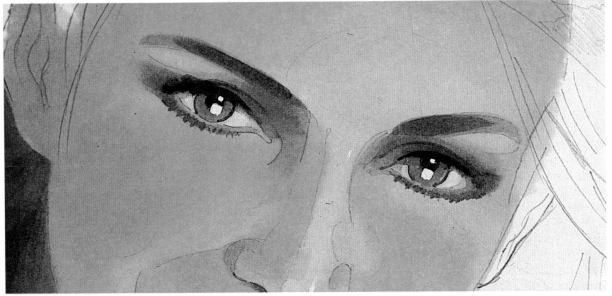

Size, presentation, and preservation

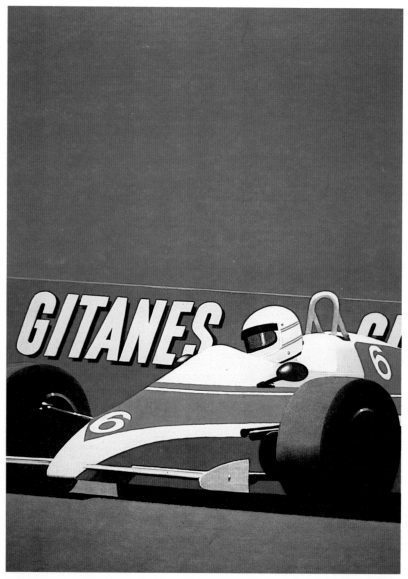

Left and right, two examples of white obtained from the white of the paper, without the help of gouache.

Trees

Nothing is better for a good landscape than mastering the technique for painting different kinds of trees. We offer some simple examples, divided in two stages for better demonstration.

Size, presentation, and preservation

We know that we can hardly expect big illustrations done with the marker technique. The reason for this limitation is that we work in strips. The longer the strips are, the less parallel we can make them, and ink has more time to dry before applying the next ones. Color, then, will not blend, and the strips will be visible. We recommend 21 × 29.7 cm (8½ × 11 in.; or double the same measures, according to what size pad is available on

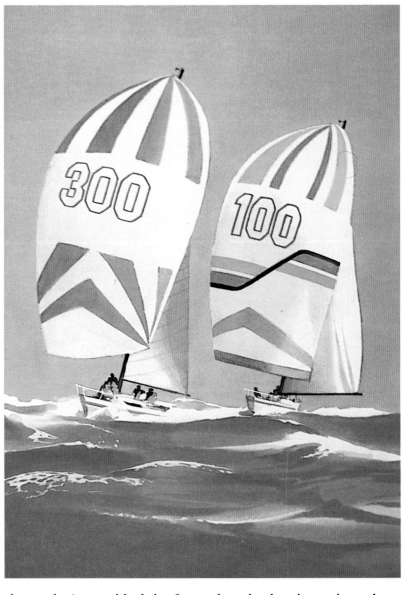

ments contained in paint. But the problem does not only affect markers. If you use pens or anilines for your drawings, you must already be familiar with fading. A good job done with these media can become ruined by the sun and also by the ambient light, although less quickly. These inconveniences, however, do not trouble the layout artist much since his illustrations know a very ephemeral life. Our advice, then, is to store your illustrations in a large folder as soon as the last touch of color has been applied. You can bring them into light once in a while and whenever necessary. Another precaution would be to protect the drawings with a transparent plastic film or with a glass that filters out the ultraviolet from sunlight.

the market) as an ideal size for marker illustrations.

The special paper for markers is usually very light and a little transparent, so it is not the kind of paper we would use for an ideal drawing. In order to work more comfortably we should paste the paper to a harder backing, preferably with spray glue to avoid an excess that would alter the colors. The backing should be bigger than the drawing so it can later take an adequate frame, a cardboard one or the more classical passe-partout.

At any rate, drawings done with markers are fugitive to light and can easily lose part of their original brilliance if we are not careful. The reason is simple: markers use ink, and ink contains coloring elements that do not resist the effect of light as much as do the pig-

Introduction to the exercises

Introduction to the exercises
We finish here with the chapters devoted—somewhat in theory—to the possibilities of painting with markers. Now it is time to check if our teaching has been effective and if the reader masters the three techniques for painting with markers: the parallel, the sweeping, and the blending techniques. It is necessary to try and try again, practice as piano students do—scales up and scales down—until they master the keyboard. Do again the exercises suggested in this chapter until you are satisfied with the results. Try new images, even simple and schematic ones such as balls, booths,

public benches, flags, using the three techniques described. It will then be easier to use the last part of this book, in which we invite you to try more complex paintings of some specific subjects in all successive stages of painting. These subjects, like most in this book, belong to Claude de Seynes. His comments while working on them will be your best guide. We will learn about an expert's methods, his way of working, and the materials he uses.
A warning: the makes mentioned in this and other parts of the book can vary or be changed for others. The quality of the colors, for example,

is almost identical for different makes. We should be able to adapt to the material available locally. As for the paper, let's try several kinds before deciding on the one that suits best our requirements for transparency, ink absorption, and properties relative to the colors we use.

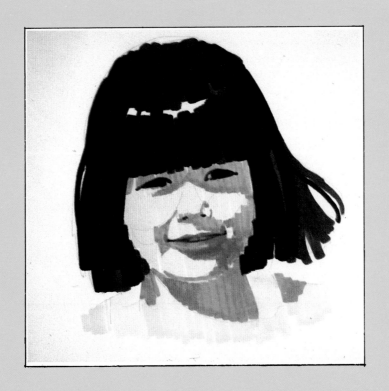

PRACTICE
EXERCISES

IMPORTANT NOTICE
Although the chapter devoted to the range of colors regularly used by professional artists (pages 22 to 25) features the Pantone markers, the authors of this book used Magic Markers for the following exercises. For number references, then, the reader should follow those of the Magic Markers when doing the exercises.

The change of markers does not presuppose a higher or lower quality to any one of said makes. Pantone and Magic Marker have similar qualities and give similar results. The change has been an arbitrary decision of the authors of this book. They, like most professional marker users, have the complete range of both makes at their disposal.

Bridge at Chatou

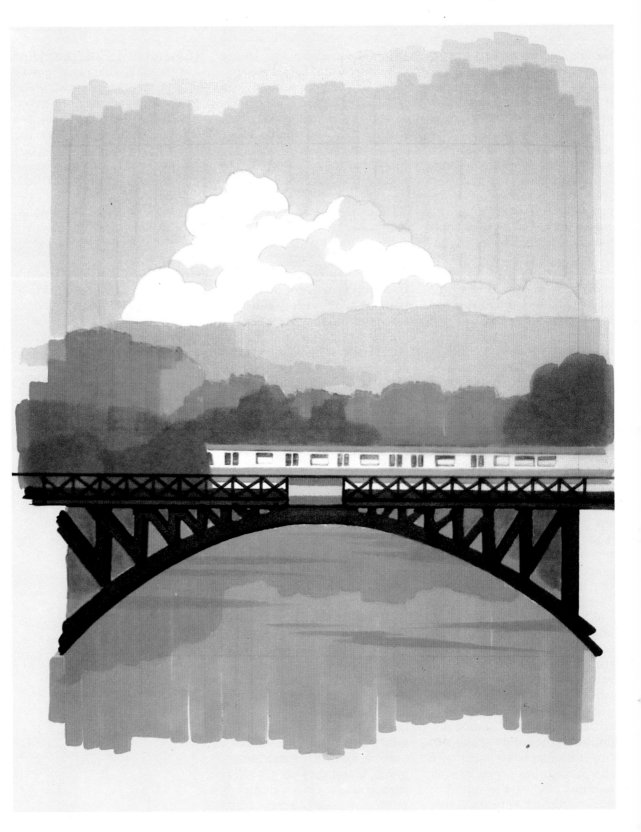

Bridge at Chatou

Before starting any of the exercises, it is a good idea to check that all the material we may need is within our reach and ready to use: markers in order in front of us, pencil (neither too hard nor too soft) well-sharpened (not too sharp to avoid ruining the paper), a soft wide brush to wipe the drawing after erasing, an eraser, and a soft cloth or some tissues are the most commonly needed accessories. It is convenient to put two or three sheets of paper under the working sheet to avoid staining the table in case the ink penetrates the paper. Magic Markers were used for all the practice exercises illustrated here, and the names and numbers in parentheses throughout the following text relate to this make. Equivalent colors will be found among many other makes of markers.

The drawing
We have drawn the outline of the main elements in pencil. The Bridge at Chatou is reproduced in a large format on purpose, so it can be traced or copied by transmitted light. The basic drawing, then, will not be a problem for the reader in this exercise. Why the pencil? Because it helps delimit the light areas (sky and greenery) from the dark ones (shaded foliage, bridge, etc.) and helps locate the marker strokes. These will almost disappear as the colors are added, but not completely, and with this the drawing attains a softer and more delicate aspect. The basic structure appears lightly outlined, and the drawing

seems more elaborate. In the case of the bridge, the iron-work can be accentuated with a black fine-point marker conferring on it the solidity and precision of the metal. These small touches with the same marker can be delayed to the end of the painting.

Blue as the basis
We now have a meticulous drawing with a bridge and a train outlined but freer in clouds and greens. We should remember before we start painting that it is convenient to limit the number of layers of color, since we can always come back to the first colors to stress tones or effects. We have already said that the principle for painting with markers is the same as for watercolors, that is, it goes from light to dark. The contrary is not possible. For example, the sky blue (4 to 7) can be the background for the sky and also for the hills and the water, because all far-distant tones have a bluish tendency due to the atmosphere. Use the broader side of the marker nib to draw the strips, from the top down and from left to right, slowly but steadily, so the next strip will blend with the previous one and the solid color will be relatively homogeneous. But as we shall see in the finished illustration, the borders are visible; only the result is not a drawback but a feature giving the image more volume. We have become skillful, our strips are parallel, and they do not overlap too much. Good. But let us be careful since the color must find its limit in the pencil lines.

If the area over the pencil line has to be darker, passing over it is no problem, but if it has to be white we have to avoid spreading the color over the border. The clouds over the horizon are pure white, so our marker must not go over the pencil lines. Some parts of the clouds are blue, but this is because they are not illuminated by the sun.

The sky
Once the ink for the sky is dry (approximately two minutes), apply a soft mauve (502) over it to warm up the first blue, making it more luminous from the transparency effect. The basic blue will create the shadows in the clouds. When this part of the drawing is done, we can consider it finished.

The far distance

In the horizon there is a hill full of trees. A buttercup yellow (708) over the initial blue will give the hill a greenish-blue tint, typical of the far horizon and especially far trees.

The trees

Cover the greenish surface with strokes of a fresh, luminous green. Wait until it dries and apply a second coating, although irregular this time, with a stronger and more intense green (600), leaving some spaces untouched. Wait for a few minutes, and when the color is dry emphasize some areas with the same green marker. The tone will become darker, because applying the same color in successive coatings makes the original tone progressively darker. This is the way to obtain a mass of trees of different tones, some light, some dark, and those shades of green that suggest the trees of a forest.

The water

The river requires a basic tone, in this case, sky blue. A second color superimposed on that initial blue, a light green (627), for example, will completely cover the first tone but will keep its transparency, always with the parallel technique.

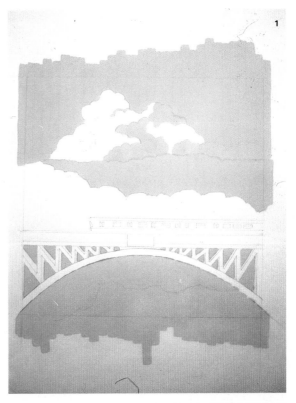

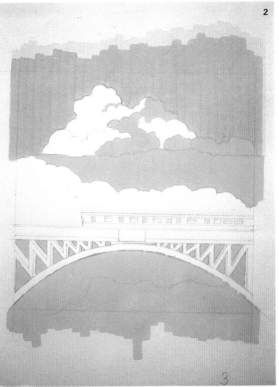

Bridge at Chatou

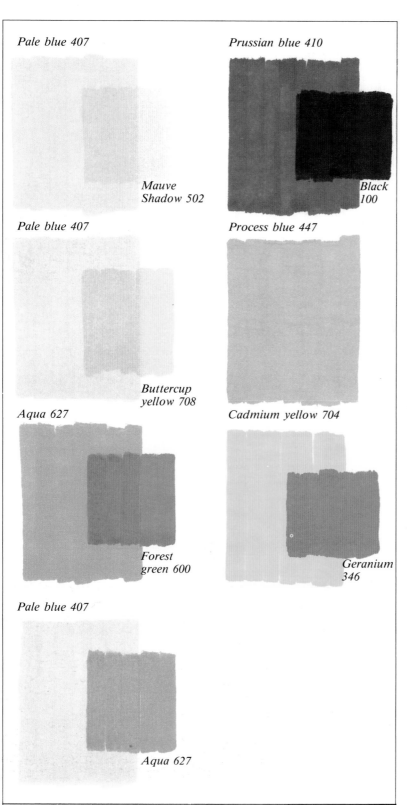

Pale blue 407

Mauve Shadow 502

Pale blue 407

Buttercup yellow 708

Aqua 627

Forest green 600

Pale blue 407

Aqua 627

Prussian blue 410

Black 100

Process blue 447

Cadmium yellow 704

Geranium 346

COLORS USED			
sky	{	Pale Blue 407	
		Mauve Shadow 502	
distant greens	{	Pale Blue 407	
		Buttercup Yellow 70◆	
near greens	{	Aqua 627	
		Forest Green 600	
water	{	Pale Blue 407	
		Aqua 627	
bridge	{	Prussian Blue 410	
		Black 100	
train	{	Process Blue 447	
		Cadmium Yellow 70◆	
		Geranium 346	

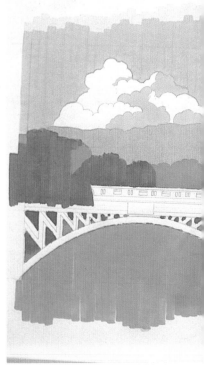

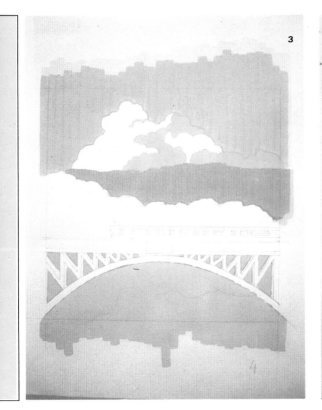

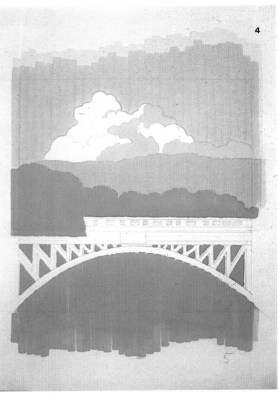

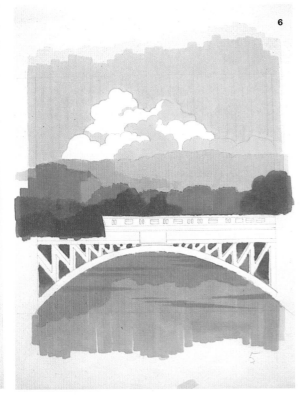

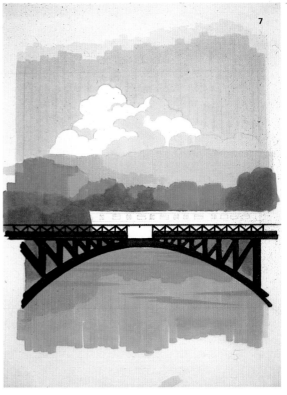

Bridge at Chatou

The reflections

When the colors are dry, it is time to render the reflections. Remember, a tone can become darker, from applying the same color over again, as we did with the trees. The new tone will be slightly darker but also more harmonious and more subtle than the tone we could have obtained with the application of a marker in the same range of color but one degree darker. Look at the example on the right and you will discover two different greens:
light green marker A
dark green marker B
Over a first layer of A, when the ink is dry, apply a second one of the same. The result will be a darker shade but not too dark. If we apply a layer of B, the shadow will be more noticeable.

For the Bridge at Chatou this different grading of reflections can be obtained using the same water-based marker—green— in superposed and successive layers (as de Seynes did in the example) or with the darker green already used for the trees (in this case, the reflections will be sharper). This system will teach us how to obtain subtler tones by applying the same marker to a basic color background.

Bridge and train

The landscape in the background is already finished. We must now paint the bridge the train is crossing. Use Prussian blue (410) to carefully paint the big steel beams with the smaller side of the marker tip and try not to touch the green in the river. If the area is too small, do not use the strip technique. The sides of the bridge can be done in two different ways:

—With a little skill, use the same Prussian-blue marker, whether its edge or its angle, for all the ironwork. The whole bridge will then have exactly the same tone.

—Choose a fine-point or medium-point marker that matches the width of the ironwork, in the color nearest the rest of the bridge. But remember, the train, painted in a lighter tone (447), goes behind the ironwork. According to the principle "from light to dark," it is convenient to paint the blue of the train before painting the beams.

Keep for the end the touches that will give a distinctive seal to the illustration. First, a few black lines (fine-point marker) in the beams to indicate the shadows. Later, to top it all off, add a few yellow (704) and red (346) strokes for the signal panel. This completes the illustration.

Castle in the Pyrenees

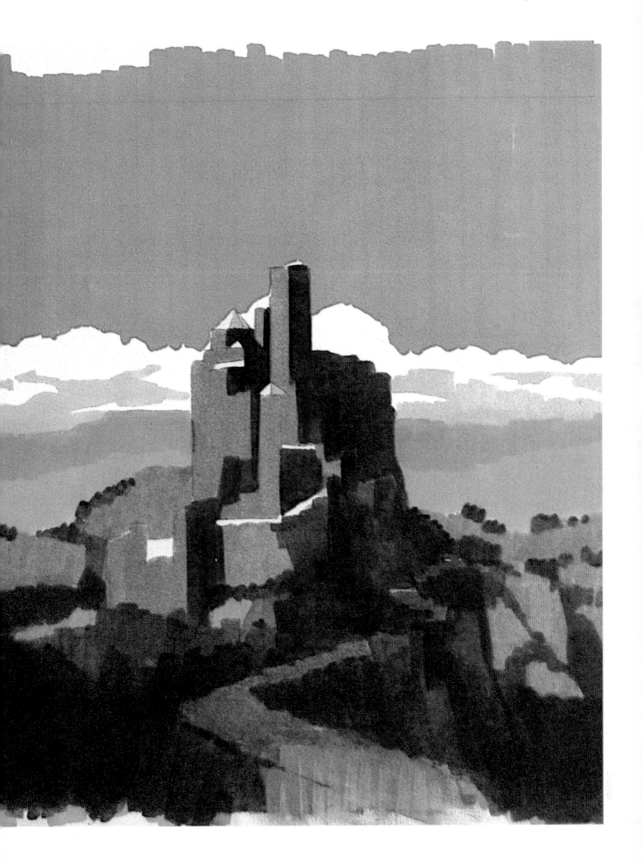

Castle in the Pyrenees

This second exercise is a mid-day landscape. The light is harsh, and the contrasts are striking (as it usually is in the sunny countries). The illustration is a good example of the vertical painting technique already described for the Bridge at Chatou, but the result is less obvious, and it looks more like a painting. The colors have more tones, and the strips of color tend to be more slanted and blend less noticeably. There are four or five shades of green achieved by successive coatings of the colors.

Sky and background

As usual, we begin with the background and the lighter colors before going on to the darker ones. This will not be the case in the upper part of the sky, where the artist wanted an intense blue like process blue (447). The strokes are vertical, regularly applied from left to right and from the top down, slowly and steadily. If the marker is new and full of ink, its flow will automatically blend the strokes a little, thus conferring on the sky more unity. Each stroke should stop at the edge of the clouds but without much precision. The white paper will define their shape. With the same blue, draw a horizontal strip under the clouds and short vertical strokes, and then complete the lower part of the sky with a greenish-blue (627). In fact, this underlying area suggests an undefined horizon, neither sky nor ground but both at the same time. The shaded part of the clouds is done with the same tone suggesting union with the horizon.

The ground

Now that the overall blue tone that will highlight the illustration has been applied, we can pay attention to the different kinds of ground. We will leave the castle blank but for a few touches of yellow to suggest the blazing sun on the old tiles. Remember that so far we have only used two kinds of blue. The yellow tone (708) used for the roof will also be right for the ground surrounding the castle, always in vertical strokes and leaving the path blank. Why this yellow? To warm up the green we will use later on, we must use a warm tone resembling that of the grass withered by the sun. Once the ink has dried well, use medium green (627) all over except on the path. The general atmosphere of the illustration will acquire a certain unity, while the relief still lacks strength in the sky area. Here is where all our artistic sense has to act, trying to enhance the irregular aspect of the ground covered with Pyrenean vegetation by means of different shades of green. Two markers will be essential for this: light green (627) and dark green (626). Except for some parts, they will cover the initial medium green serving as a background. As we can see in the illustration, we will have to play off both tones to suggest the light and shade of the ground, more or less covered by bushes. The contrast between both will create the relief and the diffused light. In some cases it will be necessary to use the same dark green several times to obtain an almost black

tone (for example, foreground left and right of the path and the depth of the cliff to the right). Sometimes just a touch of green will be enough (shrubs in the background behind the castle).

The castle

Let's not forget the castle. After a succession of images, we will notice that the castle has also achieved a certain color, like that of the ground. At the beginning, a pure brown (331) and a grey (6) for the shadow were enough, but as the ground gains strength, some parts of the castle (the walls in the shadow, for example) grow in density and tend to look like cardboard. Apply then green (646 and 611) to the shadows of the walls for more volume and to help insert the castle better in the ground where the building lies. We will thus obtain a consistent bulk firmly set on the ground and emerging from the rock. As for the path, it has also acquired the hue that surrounds it, a mixture of ground and green. The illustration is now complete. The bottom part has been treated more freely than the Bridge at Chatou. The shaded masses are slightly slanted, and that leads our eyes to the center of the drawing, improving the illustration. Let's keep this in mind when dealing with a shape in a freer style with systematically vertical strokes introducing sweeping lines, which are broader and livelier and follow the shape and character of the painted object more closely (see the Louisiana House). Seeing the illustration from this

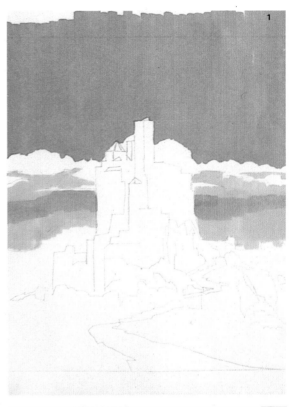

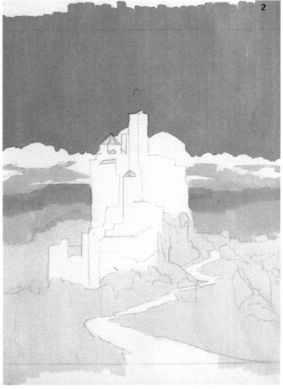

Castle in the Pyrenees

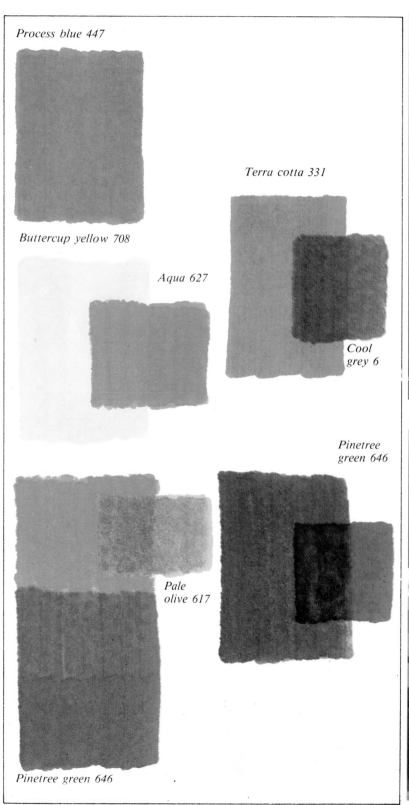

Process blue 447

Buttercup yellow 708

Terra cotta 331

Aqua 627

Cool
grey 6

Pinetree
green 646

Pale
olive 617

Pinetree green 646

COLORS USED

Sky **Shadow of clouds**	{	Process blue
		Aqua 627
Foundation color **of the ground**	{	Buttercup yellow 708
		Aqua 627
Castle	{	Terra cotta
		Cool grey 3
Grounds	{	Pale olive 6
		Pinetree gre

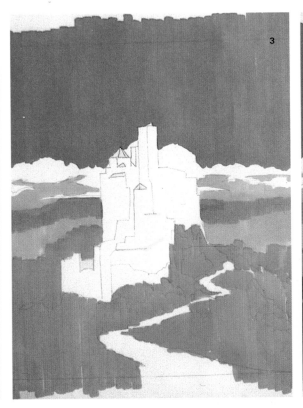

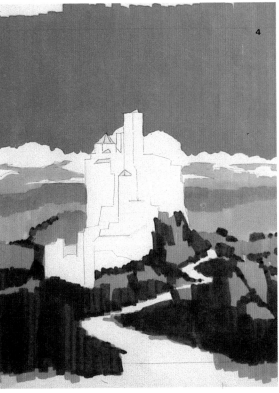

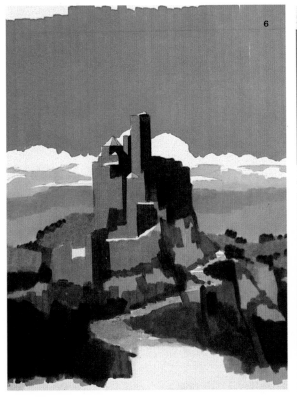

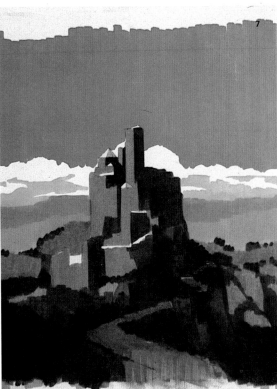

point of view requires much skill, confidence, and also inspiration. Instead of applying the strict rules of the method, let intuition lead our hands. What great satisfaction when we reach the desired effect! The general aspect of our illustration will be brighter and more dynamic, and it will lose that primary-school-like quality of the first exercises. But before going on to that stage, let's see the way one draws a human face with a marker.

Alice's portrait

THE PARALLEL TECHNIQUE A

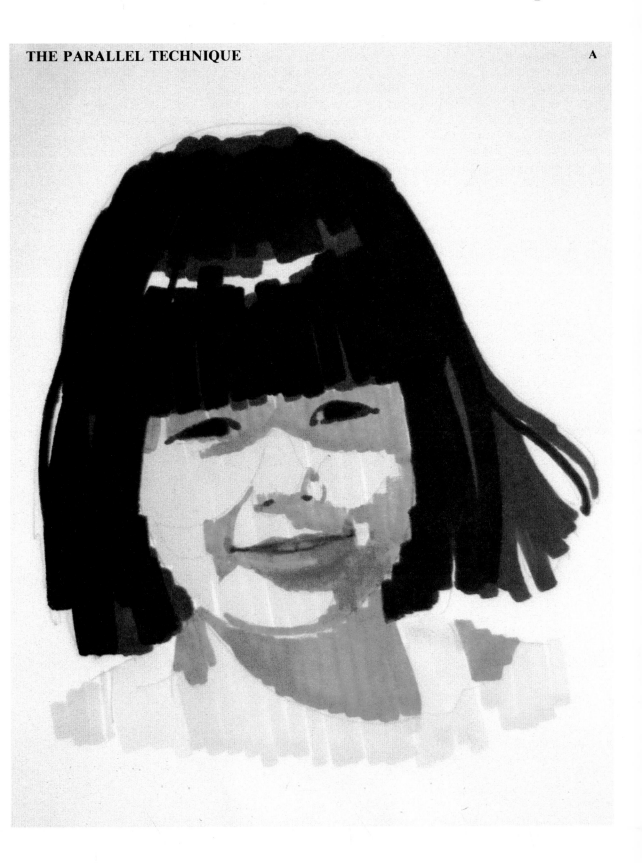

Alice's portrait

The portrait is still a favorite genre for painters and illustrators, and so we have thought of one as an exercise. In this case, we have considered it interesting to use two methods of painting, the parallel lines and the blending technique. Let's review the latter. The idea is to obtain a surface with a solid color using the marker as if it were a watercolor brush, quickly sweeping the surface with a to and fro motion. To obtain this effect it is essential to paint fast so there will not be any traces of the marker. The technique is obviously more difficult than painting in parallel strokes, because the ink from markers dries almost at once, and the blending effect can only be obtained precisely when the ink is still wet. A little practice, however, will enable us to achieve this effect that is so similar to that of the airbrush.

Why the blending technique?
On one side, the blending technique best expresses some aspects of nature (the sky, the sea, the face, the skin...), and on the other, it permits the most subtle effects. The blending, however, does not interfere with the other techniques. All of them are valid if well learned and correctly applied, but blending offers results that are different from those obtained by other procedures. Suppose we have already tried the technique on several sheets of paper and are quite satisfied with the results. It is then time to remember two important points:
—To obtain good blending,

our marker must not be overworn, the ink must flow freely and penetrate the paper. A dry medium-point marker does not help the blending. We should not use it if it scratches the paper and its stroke is not as full as when new. A marker that slides over the paper will be ideal.
—Blending is not an adequate technique for large backgrounds. We would not have time to come back to the original stroke before it dried, and the tracks would then be visible. For attractive and well-finished backgrounds, Claude de Seynes uses the wick from Magic Markers applied directly lengthwise over the paper. He can cover bigger areas more quickly this way. Well then, we already know that according to the way we use our marker we can obtain two different results, or textures, if you prefer it. We can see this by comparing the two series of illustrations for Alice's Portrait. The parallel technique was used for group A and the blending technique for group B.

Group A
The different steps in this series are simple if we have practiced painting in vertical strokes. The subject itself is not complicated, and its values have been reduced to the minimum.
—Apply the flesh tone (812) evenly over the face. This is the lighter tone, but it covers the pencil-drawn features without hiding them (remember to use a pencil that is not very soft to avoid mixing the ink with the

graphite). Outline beforehand the areas that will be shaded, and you will avoid problems later. This face can be compared with a geographical map where the different countries show their borders with a different color for each country.
—Once this first layer is dry, apply a darker flesh-tone marker (302) over the areas that will be shaded (by means of vertical strokes). A certain relief is already apparent in Alice's face.
—Now use a very light red-rose tone (369) for the lips. Finally, add the darkest color (262) for the hair, leaving some blanks for the reflections and the eyes. This step should be carried out very carefully, be-

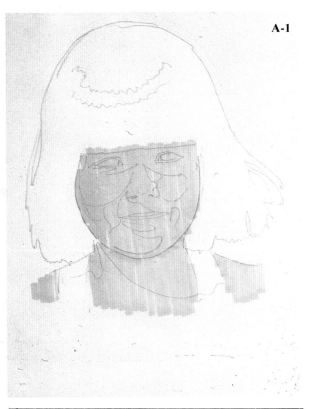

A-1

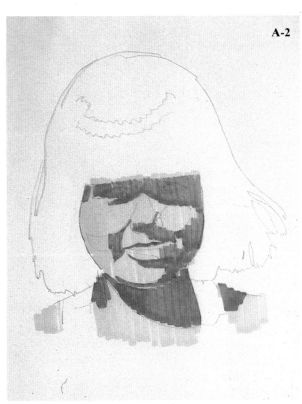

A-2

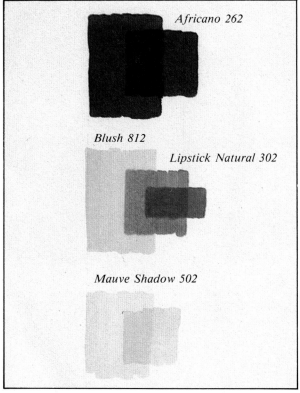

Africano 262

Blush 812

Lipstick Natural 302

Mauve Shadow 502

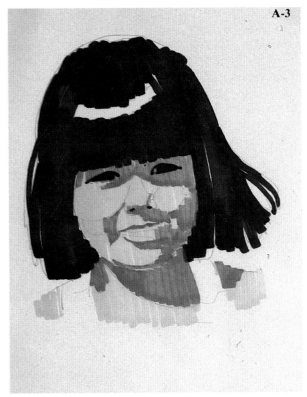

A-3

Alice's portrait

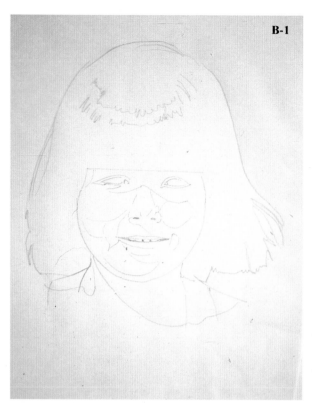

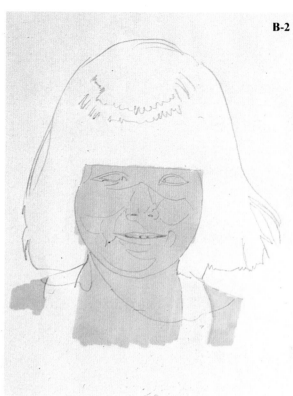

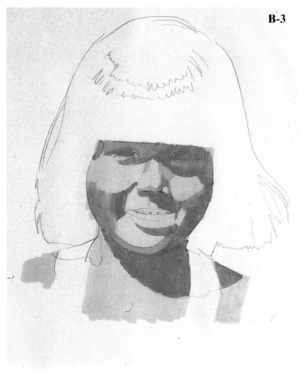

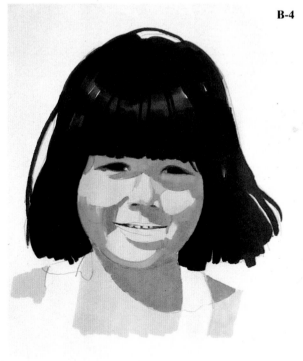

THE BLENDING TECHNIQUE B

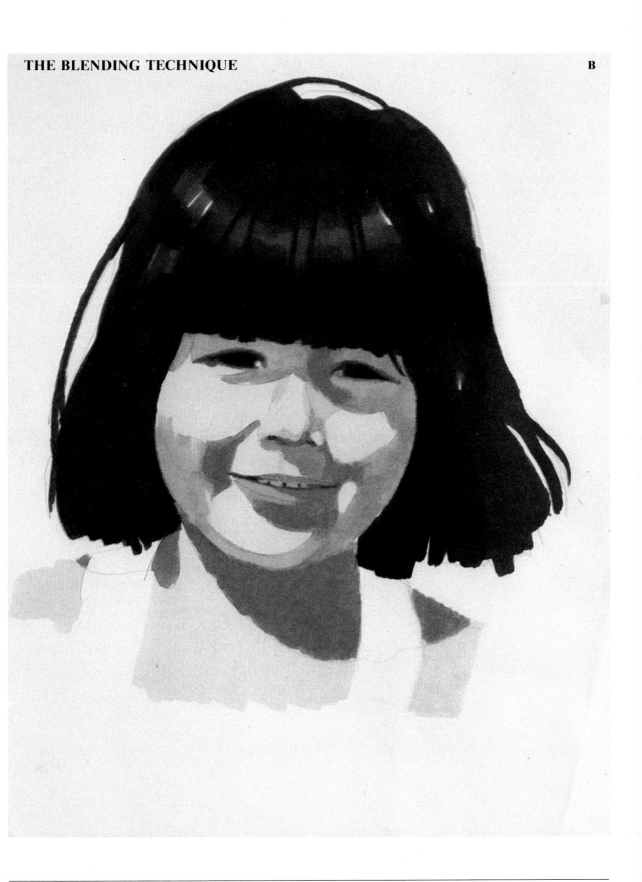

Alice's portrait

cause the slightest deviation can give the portrait a cross-eyed appearance. It is the most critical part of the drawing, and it needs all the attention it can get. For these minute details it is advisable to use a fine-point marker. Later, if we want to, once the composition is dry, we can stress the hair with a further application of the same dark brown that we used before. A few lines following the hair blowing in the wind will give it flexibility. Finally a little mauve will do for the upper part of the dress. That's it: The portrait has been painted using the vertical parallel technique. Now it is time to use the blending technique, and then we can compare the two.

Group B
—We will not describe each step. The process is the same and so is the range of colors. The only difference lies in the

COLORS USED

face	Blush 812	hair	Africano 262
shaded areas	Lipstick Natural 302	dress	Mauve Shadow 502
lips	Pale Rose 369		

way to use the marker, sweeping the surface in this case. Instead of meticulously applying vertical strokes over the face, we will sweep the whole area to and fro and in all directions. Since the ink is still wet, there are no tracks left.

—While the ink is still a little wet we apply the flesh tone in the same manner but a little more briskly over the areas to be shaded, respecting the shape of the face. We will notice how the tones often blend and the strokes disappear once in a

while, giving the skin tone a certain softness.

—Finally we do the hair, painting the paper thoroughly so that the tone will be deep.

Conclusion
These two illustrations have been treated differently. In the first case, the technique is simpler but still full of charm. The second one is more elaborate and requires greater skill, but the result looks more spontaneous, fresher. Let's practice both styles often.

The Louisiana house

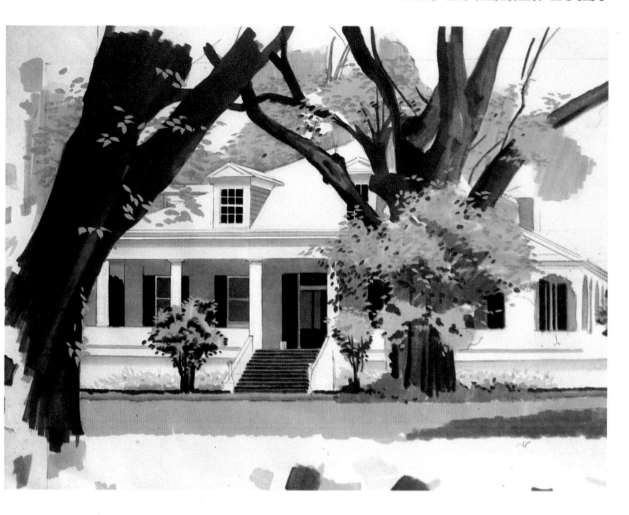

This illustration has been done with the sweeping technique described in previous pages. The drawing looks quite rough in some parts. The house, for example, looks more detailed than the trees surrounding it. This exercise really shows us how to make a few trees look like something more than just a line of undefined vertical strokes. To keep the illustration uncomplicated we avoid the sky and concentrate on the leaves. The exercise is more complex, because it requires the complete involvement of the artist and a lot of attention to avoid mistakes when choosing colors. As a reward, this Louisiana House will allow us to enjoy an artistic experience close to painting, in which inspiration counts for as much as mastery of the technique.

The first step is to make a pencil sketch, very schematic for the leaves and the branches and somewhat more detailed for the house, the windows, the flight of stairs, the pillars, and so on (you can use a ruler to help you draw these). Mistakes, carelessness, or a trembling of the hands are fatal to architectural drawings, while more imagination is acceptable for details related to nature, vegetation, and so on. As a general rule, in the field of ar-chitecture the pencil lines should be seen after color has been applied. Once painted, we will realize that the composition has improved.

The Louisiana house

Application of color

The idea is to work with complete freedom in choosing colors. The author, for example, chose several kinds of green for the exercise. Remember that we have left aside the parallel technique.

—Instead of systematically filling the surface with green strips (627 or 606), we sweep it fast and freely in any direction (or rather, in the direction in which we want to create a feeling of motion). The more we move the marker, the darker the color, while the stripes blend without disappearing altogether. This color nucleus will give life to our illustration. If this coating (illustration 1) is satisfactory, we should not retouch it, or we can ruin everything by destroying the initial effect. In illustration 5 the basic leaf color is perfect, somewhat subjected to the effect of light on the leaves themselves.

—With a darker (646) but matching tone, we sweep the trees using the same technique, that is, quickly moving the marker in the direction of the trunk and branches and going back fast to the shaded areas, always with the same marker and leaving the lighter areas untouched. The shadows will then become deeper. It should be quite clear that right from the beginning we will have two tones in the trunk and branches corresponding to the shaded and lighted areas indicating the main masses. Later on, when the color is drier, we can go over the shaded areas with the same marker until reaching a reddish-black tone. The satisfactory contrast thus obtained will determine the volume of the trunk and branches.

House and garden

We now have the general color for trees and foliage. Before we finish this part of the illustration, we should begin painting the house and the foreground of the garden. The shaded elements should be a medium pale blue (407) and a slightly darker grey (3) evenly applied. Some of those areas will later be painted a much darker tone similar to that of the tree trunk to keep the general harmony of doors and windows. The light blue tint will add depth to the verandah. The same is valid for the stairs and the steps in the shadow. We have to be very careful with these details, to keep the hand steady and have regard for the pencil drawing. The shadows have to be rectilinear. The frames of the windows can be retouched using a thin brush soaked in gouache and those of the verandah with a tone similar to the pale blue (646 or 410). The dark green-black tone used for windows and doors highlights the white and grey harmony prevailing in this house. We should be very precise with these details. The grass in front of the house can be a medium green (606 or 600) reinforced by a darker green for the border of the path. Use a light and a medium yellow (704 or 707) to indicate the presence of lively colorful flowers. A few spots can complete the suggestion. We can show our initiative in the garden, applying touches of color according to our inspiration.

Finally, we will leave the sky and the roof white to keep the illustration uncomplicated.

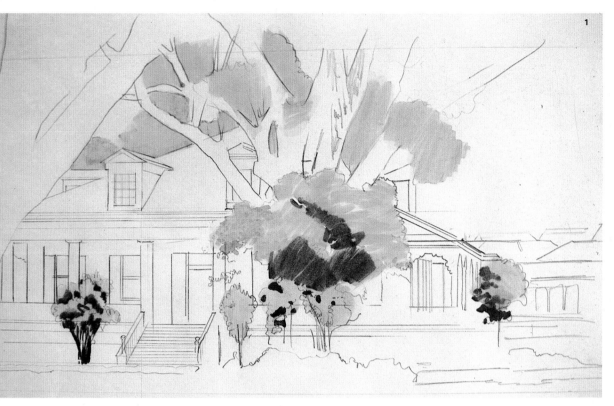

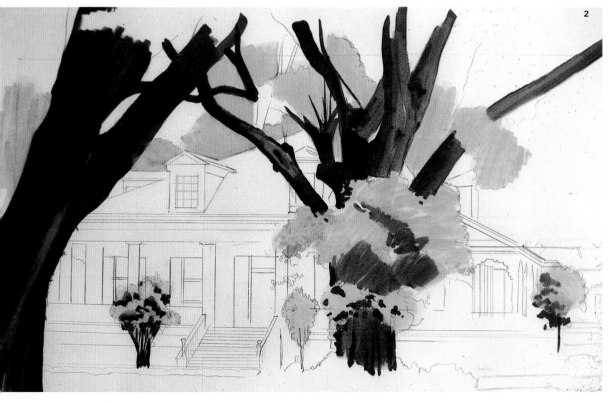

The Louisiana house

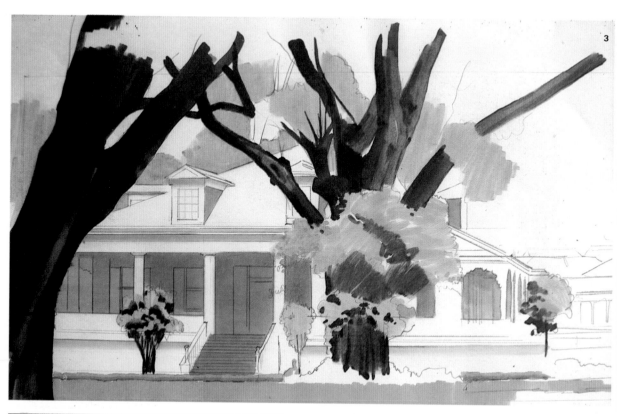

3

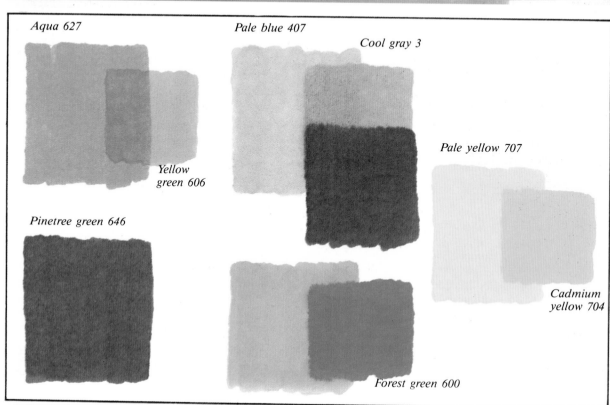

Aqua 627

Pale blue 407

Cool gray 3

Yellow green 606

Pale yellow 707

Pinetree green 646

Cadmium yellow 704

Forest green 600

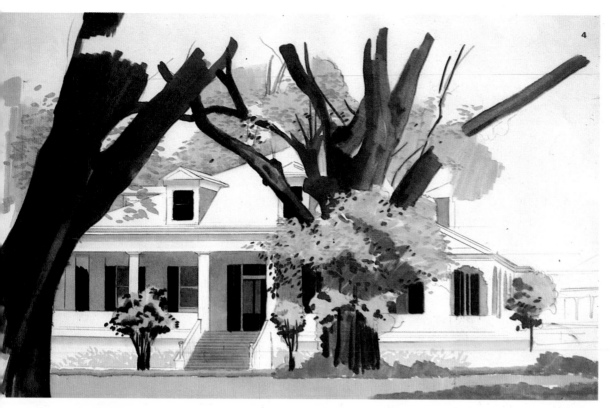

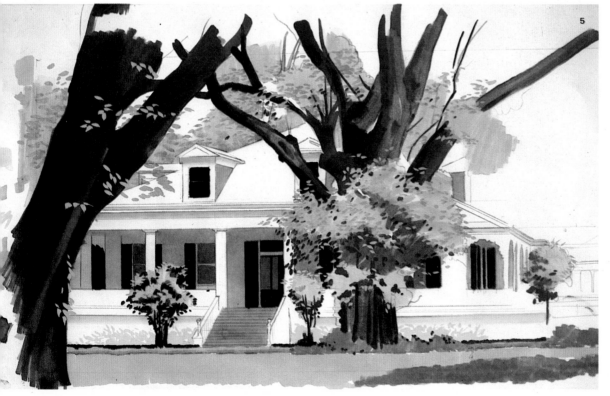

The Louisiana house

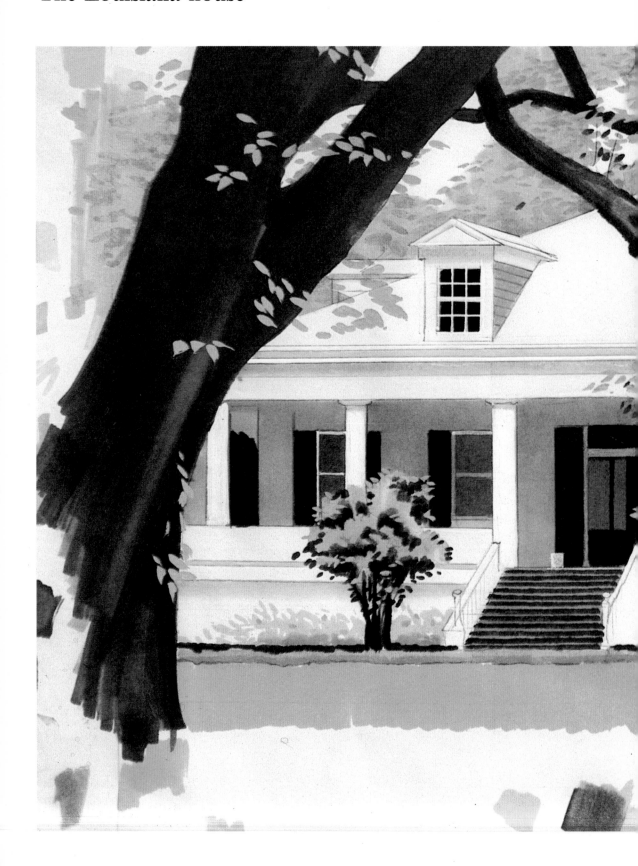

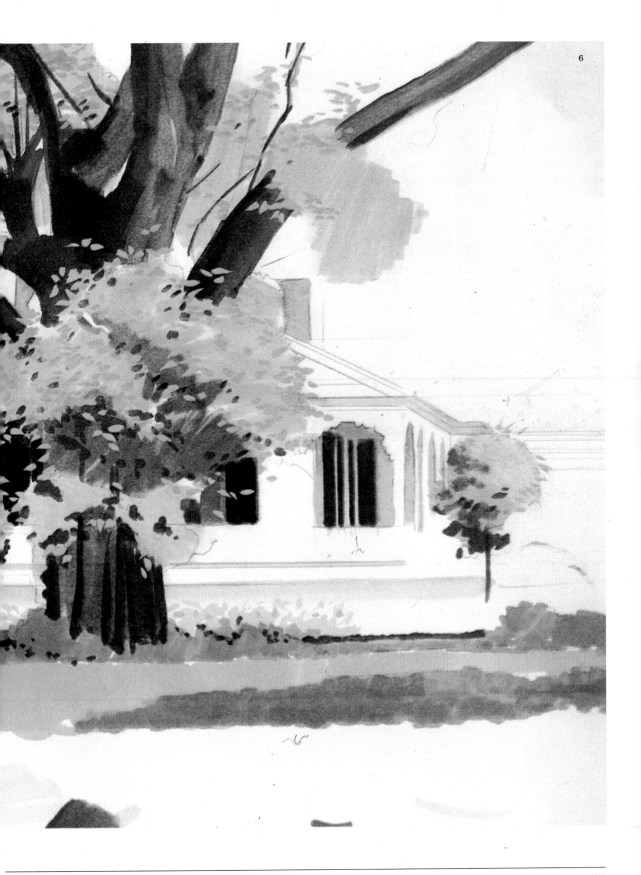

6

The Louisiana house

Finishing touches

This last coating is done by means of light touches with the narrower side of the marker tip. At the beginning of the exercise the foliage was barely suggested by sweeping masses, so now we can make it livelier using the same green marker to touch it here and there to imitate the effect of leaves hanging in the air. We can alternate these touches with some in the initial green tone to avoid monotony. The window frame can be finished with gouache and a no. 3 sable brush. Those areas, as well as the leaves just mentioned, can be touched with the green ink used at the beginning. It is only logical that we use this gouache for the window frame and the reflections on the leaves, since it gives a bolder result and a very luminous tone in the finished composition.

COLORS USED			
trees	Aqua 627 or 606	lawn	Yellow green 606 Forest green 600
tree trunks	Pinetree green 646	flowers	Pale yellow 707 Cadmium yellow 704
shade of the house	Pale blue 407 Cool grey 3		

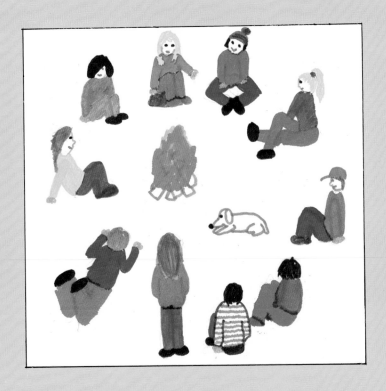

MARKERS
AND CHILDREN

The marker at school

It is quite evident that a child very often uses a marker to let the adult world know what his most intimate feelings are. These little "masterpieces," elementary but very indicative, show fright, hope, and wishes all at the same time.

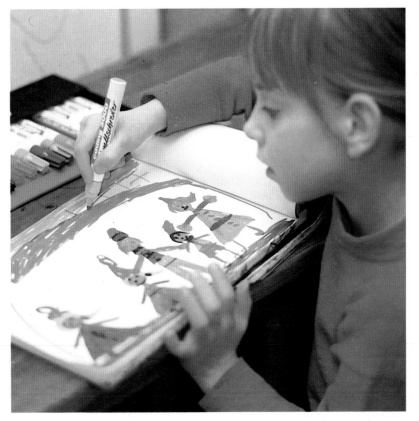

The appearance of the marker was very important to all the children in the world. At last they could paint directly, without the logical precautions needed in other media, without stains! No more water to clean the watercolor brushes! No more sharpening colored pencils with leads that break every few minutes! It is true that the marker is all that in one single item, but do they know how to get everything out of it? Do they really know what a marker is like? In other words, are the instructions given so far valid for them? And more important, will you persuade your children to know the marker? First, we should know if using markers is beneficial within our present educational scheme.

The marker at school
In order to answer this and similar questions, we enquired at some state schools and private art schools in France. The sampling was not very large, so the answers cannot be taken as definitive for the schools of the country or those of the rest of the world. At many schools, children of a certain age who like drawing can attend some extra classes where there is no formal instruction. The teachers can then create real workshops for children. They learn drawing, perspective, and other essentials, and they are taught more drawing than painting. The teachers usually reject the marker, because they consider it a "dull modern instrument." The school teachers had the same ap-

The marker at school

proach. They all preferred the colored pencil, gouache, or watercolor to the marker, so our enquiry was stopped short almost at the very beginning. At nursery schools, however, the marker is the king of drawing. The children between three and six years of age spend a lot of their school time painting their drawings. The teachers of children these ages do not teach their pupils how to draw but rather use drawing as a means of expression. It is through their drawing that the children express their problems and their small familiar universe. But why the marker for this function? A teacher answered: "Because the children prefer it!" Nothing could be clearer or more indicative. The marker is easier to use than colored pencils, and the result is immediate: you paint and draw at the same time. Obviously, it is not a matter of the teachers imposing a certain way of drawing. It is rather the child's attitude that will show his or her personality and perhaps problems.

First, the child gets to know himself and draws his own portrait. He uses the marker as if it were a pencil, but he uses a different marker for each part of his body. The result may not be considered an artistic achievement, but it is certainly most interesting, like the stick figure representing an unknown child (1). This self-portrait was done by William, who was 5 when he painted it (2). This character, which reminds us of Charlie Brown, is typical of children's drawings,

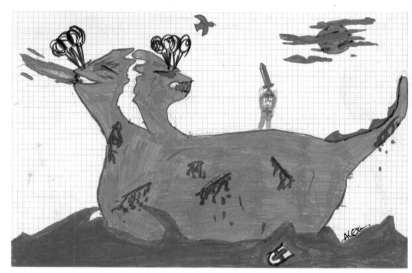

with those arms ending in fingers out of proportion and often too big.

Children improve their techniques when they get to know the marker better. They draw using the marker and then paint their drawings, often using different tones. Drawings like the one by Caroline (3) are quite unusual, as there is no previous planning.

Drawing at nursery schools is not only a way of expression but also a preliminary step to writing. The teachers have the children draw curved and straight lines, then wavy lines, and so forth, and this makes the little ones pay a lot of attention to choosing and combining the colors. The unfinished fish by Indiana (4) is a good example, and it is worthwhile to stop and look at this drawing.

Of course, choosing colors is necessarily limited since the range of markers a school may have depends on its finances. According to what we saw, most schools have broad-pointed nib markers that are

pressure resistant. This last aspect is important since children do not moderate their strength; they draw with enormous drive, putting a lot of pressure on the brush or pencil. This is why it is not a good idea to give them fine-point markers, because such a thin tip does not last longer than a few sessions.

The colors children prefer are vivid pink, orange, red, yellow, and deep blue. There is no doubt about this, since these are the colors most often replaced.

(Left) Color, use of striking tones, vivid strokes… Children demonstrate their personal feelings painting subjects like the one shown here.

(Top right) A stick figure, very much used by children to convey the shape of the human body.

(Bottom right) Hands out of proportion are also a regular feature of childish drawings.

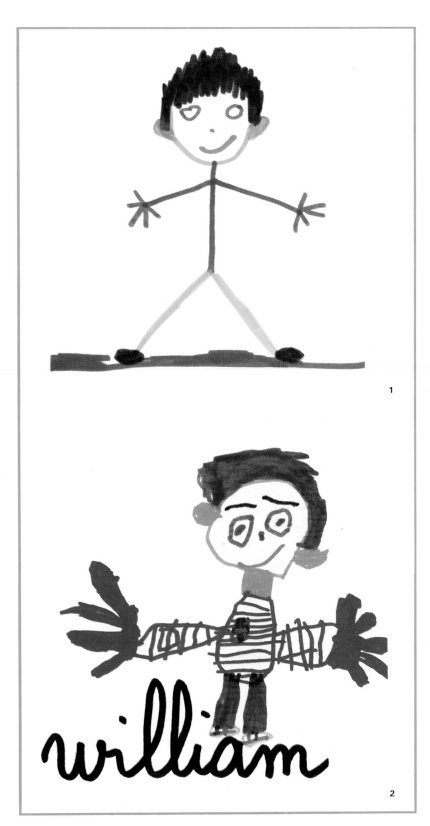

1

2

The marker at home

The marker at home

The child often uses markers for his homework, and he usually prefers medium-point markers, but the range of colors is not very ambitious. A box of ten units may have one yellow, one orange, one red, two blues, two greens, one purple, brown, and perhaps black. A box of twenty markers adds pink and other colors to the list, but tones like light pink, sea green, and light blue only come in boxes of twenty-five markers. It is better then to buy the markers singly, choosing first a range of soft colors. Children should discover the pleasure of using broad-tip markers to paint large surfaces in a few strokes. Some markers are almost anatomically adapted to their small hands.

Alcohol or water?

The reader will have decided by now the kind of marker his child will use, either alcohol- or water-based.

4

This unfinished "fish" has a certain artistic quality. This kind of work helps to educate the child's hand and teaches him to be a keen observer while preparing him for writing.

This country scene combines human figures, a bear, some trees, and other elements. The illustration was done completely with a broad-tip marker. The young Caroline signing the painting shows her tendency toward rural subjects.

Alcohol or water?

caroline d.

Protection laws change according to country although they all aim to prohibit substances that can hurt children, as well as certain ingredients in paints, varnishes, and lacquer on the outside of markers. These are metals or metallic compounds related to antimony, arsenic, barium, cadmium, chromium, lead, or mercury. The markers without these characteristics —and therefore accepted— can offend the nostrils of children (we mean the alcohol-based markers). As a general rule, then, we recommend the water-based markers. How can we tell them apart? (the label may have no indication). Easy: Put a drop of water on a piece of paper and apply the tip of the marker to it. The ink from the marker will dilute if the marker is water-based, but it will not mix with the water if it is alcohol-based.

Technique

Schwan Stabilo features seventy water-based markers with a broad-beveled tip (including twenty pastel colors) and fifty medium-tip markers. This is too many for a child, of course, but we can use the color chart on pages 26 and 27 to choose a first set of markers. The Schwan make includes small, flat markers, easy to hold in the hand. They close easily, just by turning the cap.

Paper

If we want to use the same method as the layout artist with the water-based markers, we should use a paper smooth enough so the ink can spread evenly and absorbent enough so the color will not form drops on the surface.

As we said in the previous section devoted to paper, we should try as many kinds as necessary until we find a suitable one for our children. Remember, water can form wrinkles in a thin paper. Also, some manufacturers have created specific kinds of papers that take both water and alcohol equally well. Canson paper for watercolors, fine-grain, can be suitable unless the child needs a semi-transparent kind of paper to trace an original drawing.

Technique

The illustration done with water-based markers follows the technique described on previous pages, at least as far as application is concerned.

The results, however, are not quite the same. We now face a new element, water. Let's go over, then, the differences between both kinds of ink and their reactions to similar situations. The study included on this page will show that the water-based illustration is somewhat different.

Painting backgrounds and applying the blending technique is not as easy with water-based markers as it is with alcohol-based ones. This is a drawback for children, who prefer to draw leaving the paper white. They will then have to paint in backgrounds by means of some touches of color.

Consequently, when painting with water-based markers, we have to be careful to avoid superimposing the colors (outlining the areas to be painted with clear strokes, for example), checking any changes these mixtures may have produced. Children should start mixing colors, since this will prepare them for future oil or watercolor painting, also introducing them to the fascinating world of creating colors.

In example no. 7 we applied a pale color over the whole character, adding blue to the sweater and pink to the trousers. But careful! The wicks quickly pick up the colors previously applied to the drawing. They can be cleaned by rubbing them on a piece of paper until the unwanted color has disappeared.

Which drawing to color?

If your child does not yet draw very well but has left the scrawling stage behind, he will

Density of the ink	
Alcohol ink	**Water ink**
Due to the quick evaporation of the alcohol, the resultant line is more homogeneous. When tracing repeatedly with the same color, on the same spot or area, this color will intensify to the point that it will achieve a tone that will not change anymore, no matter how much we keep on adding to this area (5).	Water takes longer to evaporate, and therefore the color is less uniform. The fact of tracing several times with the same felt-tipped pen, on the same spot, darkens the color, but the excessive water removes the fiber of the paper (5-A).
Mixture	
Alcohol ink	**Water ink**
If, after having applied a color and waiting for it to dry we wish to add another color over it, the latter will not mix with the former, speaking in terms of coloring. The tone will change, simply, by transparency (6).	Any color applied over another one will modify instantaneously, mixing one with the other (6-A).

Which drawing to color?

need more elaborate subjects for his illustrations, more artistic and not quite as simple as the ones in drawing and painting books available on the market. Since the child's drawing may be unsure, the subjects should have clear outlines to indicate the parts to be painted. The subjects can be found in books, magazines, and advertisements, or we can make them up ourselves. Now we only have to choose the paper. Shall we make a copy to start with? We know that the special paper for markers is transparent enough for our child to trace the picture underneath. What can he use? Unfortunately, the water in the ink contains a lot of elements, and the same happens with a soft pencil, a ballpoint pen, India ink, a black fine-point marker not alcohol-based....

The only thing left is a hard pencil (though its lines are not very black), the alcohol-based black marker (difficult to find) ... and the invention of the century: the photocopy.

Modern photocopiers using a dry "ink," in fact, give us this great advantage of reproducing on absorbent paper a drawing in black that the water of a marker does not affect, unlike its alcohol-based brother. You know it is illegal to make copies of copyrighted pictures commercially, but this is not your intention. Your copies are made only for personal use, and your child will then have several identical copies of the same picture to color. He will be able to start it again if he thinks he has spoiled the first, and he can also amuse himself

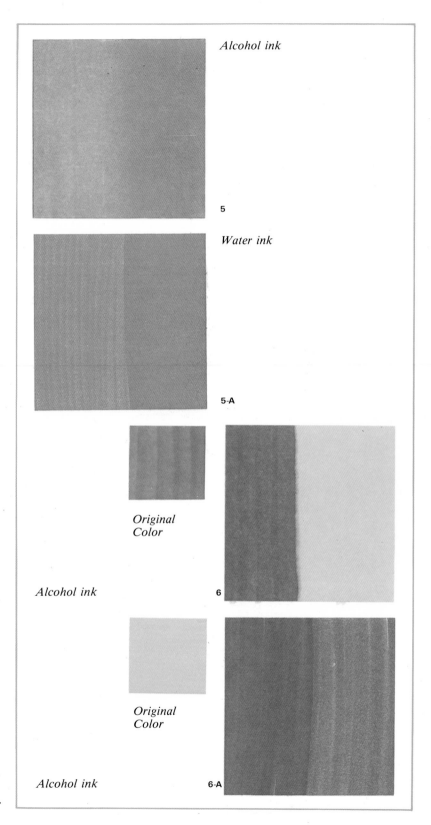

Alcohol ink

5

Water ink

5-A

Original Color

Alcohol ink

6

Original Color

Alcohol ink

6-A

The last step before watercolors

by altering the colors of a drawing.

The last step before watercolors

If the struggle between water and alcohol has been won by the latter—a narrow victory, nonetheless—the difference will still be minimal, and water can take revenge. It allows a whole series of stratagems, of professional tricks not yet explored.

To go into these techniques in more detail would mean an introduction into an artistic field beyond the scope of this book. That artistic field is called watercolor, of course, and it already has books devoted to it, including one in the same series to which this book belongs: *How to Paint in Watercolor* by José Parramón and G. Fresquet.

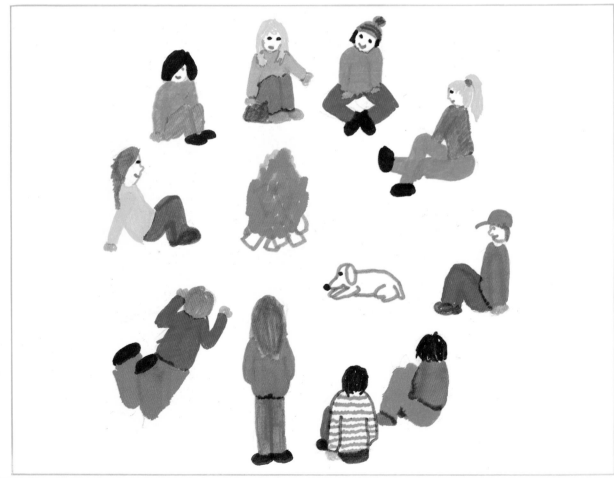